Peter Bialobrzeski Lost in Transition

Peter Bialobrzeski Lost in Transition

Essay: Michael Glasmeier

HATJE
CANTZ

I photograph to see what the world looks like in photographs.

Gary Winogrand

Ich fotografiere, um zu sehen, wie die Welt fotografiert aussieht.

Gary Winogrand

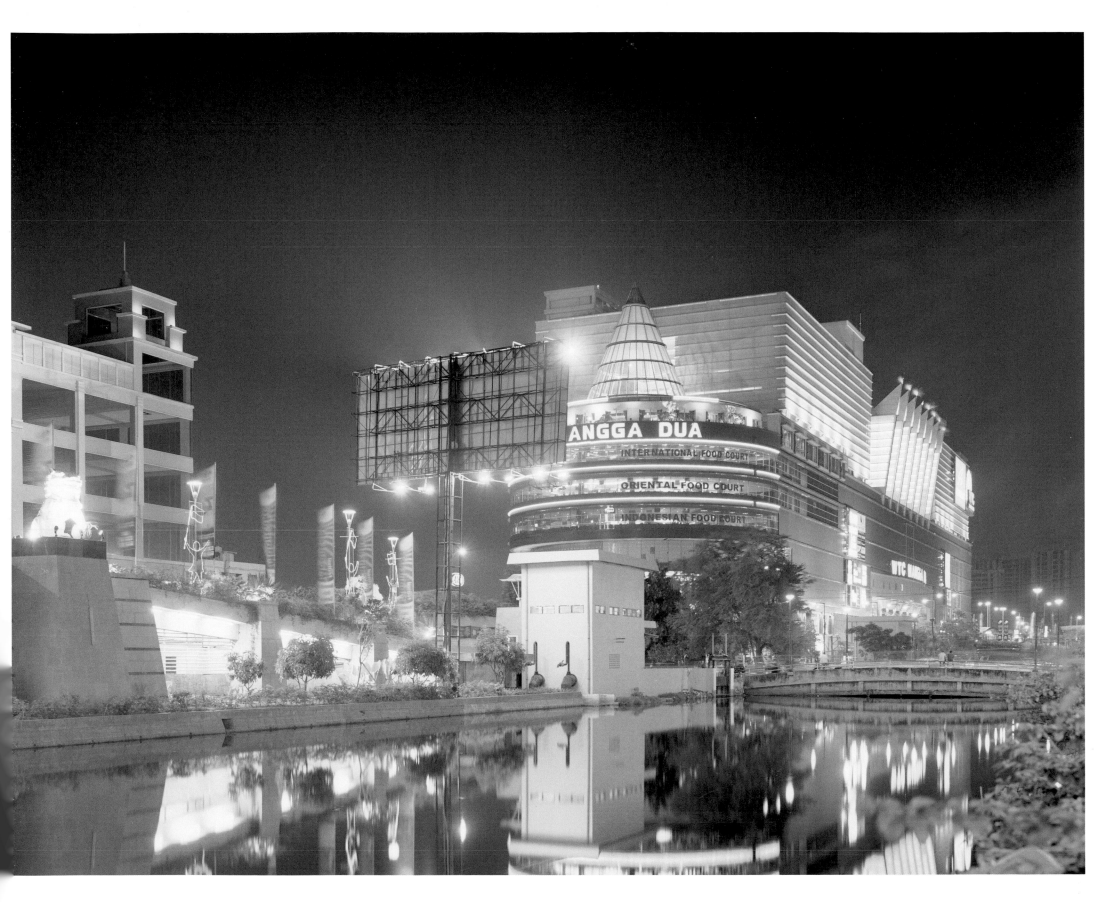

The Presentness of the Unpredetermined
Michael Glasmeier

We have images, literature, and explicit theories regarding the space that surrounds and defines us. To listen to these voices, the condition of space in our day, especially urban space, is steadily worsening. It isolates and alienates; it seems illegible, decaying, disintegrating at the speed of transportation and media—so goes the diagnosis.[1] At times distended, at times shrunken, its continual mutation and reorganization obeys the laws of the worldwide primacy of economics. It prefigures, as it were, an apocalyptic vision on earth, where we as malingerers idle over our paltry activities.[2]

This space—manifesting itself as sinister megalopolis, postmodernized city, desolate town—wants to be tamed and made livable, to be historicized and humanized, in order to avert an all too catastrophic future. For this, too, we have images, literature, and explicit theories,[3] but above all we have the concrete ideas and interventions of architects and urban planners, who lay down cultivated paths in the urban wilderness and stage a sense of orientation with splendid, emphatic buildings. Thus space remains in constant flux, yet without ever consolidating itself, as in the Paris of Georges-Eugène Haussmann (1809–1891) or finding its rhythm as in the film *Berlin: Die Sinfonie der Großstadt* (*Berlin: Symphony of a Great City;* 1927) by Walter Ruttmann (1887–1941). Instead, its functions, purposes, and conditions are dominated by a constant and apparently anarchistic process of redefinition. The old must accommodate itself unconditionally to the new, as well as to the zeitgeist of the global economy. Urban space as a "network of movable elements"[4] articulates itself discontinuously in a differentiated simultaneity of heterotopias,[5] "non-places,"[6] and palimpsests[7] in the superimposition of multiple functions.

This instability of the urban, with its marginalization even of dwelling itself, makes every aesthetic question a political one and every act of planning social. In this way both art and theory find it easy to identify wounds, scars, and inevitabilities through the mere act of showing, especially since an abstemious urbanism is rarely in view. Just as rock bands in the late 1960s routinely appeared atop garbage dumps in their television clips, the coincidence of the undefined continually and automatically provokes a new range of political symbols to embody complex perceptions. The flickering space produces its own images; and no matter in which direction the camera points, the result is political.

The same, of course, is true of Peter Bialobrzeski's photographs, and especially of *Lost in Transition,*[8] which emphatically addresses and gives visible form to this diffusion of urban space. Yet Bialobrzeski goes a decisive step further: his photographs do not content themselves with the simple appearance of transitory spaces and the incidental capture of a transitory moment—a doubling that intensifies the effect of the indeterminate and improbable. Nor are they to be read primarily as traces, as an index of reality or aids to memory.[9] All these factors, inherent in the medium of photography, do play a role in the images; yet I experience Bialobrzeski's photographs rather as assertions, intensifying the improbability of the real and driving it further in the direction of decision. These images don't just talk; they *say.*

For a helpful compilation of relevant texts from René Descartes to Paul Virilio, see Jörg Dünne and Stephan Günzel, eds., *Raumtheorie. Grundlagentexte aus Philosophie und Kulturwissenschaften* (Frankfurt am Main, 2006).
See especially the work of American science fiction writer Philip K. Dick (1928–1982) and the films based on his novels, *Blade Runner* (Ridley Scott, 1982), *Minority Report* (Steven Spielberg, 2002), and *A Scanner Darkly* (Richard Linklater, 2006).

3 Marc Mer et al., *Translokation. Der ver-rückte Ort. Kunst zwischen Architektur* (Vienna, 1994).
4 Michel de Certeau, *Kunst des Handelns* (Berlin, 1988), p. 218.
5 Michel Foucault, "Von anderen Räumen," in *Dits et Ecrits. Schriften in vier Bänden,* vol. 4 (Frankfurt am Main, 2005), pp. 931–42.
6 Marc Augé, *Orte und Nicht-Orte. Vorüberlegungen zu einer Ethnologie der Einsamkeit* (Frankfurt am Main, 1994).
7 The rhetorical concept of the palimpsest is particularly current in literary and cultural studies; for a more precise definition, see for example Gérard Genette, *Palimpseste. Die Literatur auf zweiter Stufe* (Frankfurt am Main, 1993).

8 The title makes obvious allusion to the film *Lost in Translation* (2003) by Sofia Coppola, which explores typical experiences of fundamentally untranslatable strangeness as two Americans in Tokyo (Bill Murray and Scarlett Johansson) come together in a hotel for a certain period of time.
9 Philippe Dubois, *Der fotografische Akt. Versuch über ein theoretisches Dispositiv* (Amsterdam and Dresden, 1998).

Documentation is of lesser concern in Bialobrzeski's photographs of the transitory. He takes his plate camera to the most unlikely places on the planet and uses it to transpose transitional spaces into grandiose visions. He photographs urban desolations as if they were the festival architecture of a modernism seeking to celebrate and represent itself. This contradiction gives rise to images characterized by precise order and compositional density, and thus to a concentrated photographic participation in the diffuse. In a kind of methodological incommensurability, the length of time required to view these pictures stands in complete opposition to the actual time we would be willing to spend in the places themselves. The latter approaches zero, for the irony of the transitory lies in its supposed meaninglessness and anarchistic lack of focus, amenable neither to lingering nor to closer observation.

10 See for example Ekkehard Mai, ed., *Das Capriccio als Kunstprinzip. Zur Vorgeschichte der Moderne von Arcimboldo und Callot bis Tiepolo und Goya,* exh. cat. Wallraf-Richartz-Museum (Cologne, 1996); Peter Dreyer, ed., *Vedute, architektonisches Capriccio und Landschaft in der venezianischen Graphik des 18. Jahrhunderts,* exh. cat. Staatliche Museen Preußischer Kulturbesitz (Berlin, 1985); Norbert Miller, *Archäologie des Traums. Versuch über Giovanni Battista Piranesi* (Munich and Vienna, 1978); Annelie Lütgens, *Giovanni Battista Piranesi. Bilder von Orten und Räumen,* exh. cat. Hamburger Kunsthalle (Hamburg, 1994).

In the history of art, particularly in the period from Mannerism to Romanticism, attempts have repeatedly been made to imbue transitory spaces with meaning and immortalize them in painted or drawn images. Here, too, a certain model of reality—resurrection from the ruins of antiquity—inspired the pictorial invention of the capriccio and the *veduta,* which finally crossed over into the free realm of fantasy with artists such as Giambattista Piranesi.[10] The fascination with ruins, in which the veneration for antiquity, the passion for the bizarre, and the *vanitas* theme all played an equally important role, gave rise to images whose artistic strategies were derived from the actual formal repertoire of ruined architecture, but at the same time could be read as allegories of history.[11] In German Romanticism, then, the decaying Gothic cathedral became the primary symbolic locus for an architectural model of transcendental nature.[12] In a parallel development, the fascination with construction sites found expression in the iconography of the Tower of Babel; this theme, however, was less fruitful, appearing only occasionally and not becoming prominent until the nineteenth century, above all with Adolph Menzel.[13] These motifs passed seamlessly into the early history of photography and have continued to the present. While the nineteenth-century photographic fascination with ruins was motivated primarily by archaeological concerns,[14] the two world wars of the twentieth century shifted the emphasis to documentation, giving rise to masterpieces of the sympathetic recording of destruction and violence.[15]

This extremely abbreviated summary is intended to emphasize that all of these art historical elements—the documentary character of the *veduta* and of photography, the bizarreness of the capriccio, the *vanitas* theme, and archaeological documentation—are clearly present in Bialobrzeski's photographs as well. They are the *basso continuo* that automatically sets in when we direct our gaze to the transitory, or as sociologist Georg Simmel puts it in his essay on the aesthetic experience of ruins: "The ruin creates the present form of a past life, not according to its content or remains, but according to its past-ness as such. … In these places the tension of opposites between purpose and chance, nature and spirit, past and present is dissolved, or rather, though it still exists, they nonetheless give rise to a unity of outward appearance, of internal effect. It is as if a piece of existence first had to decay in order to become so vulnerable to all the currents and forces moving in from all directions of the present."[16]

Simmel's "present" measures itself against the persistence of the ruins and at the same time invokes the unity into which the contrapuntal elements of the image dissolve as they take on visible form. Yet the reality of the last fifty years has produced a present that is alien to the romantic and the historical. The present itself is ruinous. The dominance of the economic and of changing concepts of work has caused the stable givens of urban structure to mutate into "unpredetermined spaces."[17] Factory complexes can be turned into service or arts centers, slums into interstate junctions, harbors into container parks, train stations into shopping malls, post offices into museums—or they can be demolished altogether. No change of function, no palimpsest, no destruction is precluded by the conditions of globalization. And all of this occurs with an extreme and often thoughtless rapidity from which not even the newest architectural manifestations emerge unscathed. In this pulsating present, where urban constants are continually negotiable, insistence on the heuristic value of the past seems a mere sentimental gesture.

11 Jeannot Simmen, *Ruinen-Faszination in der Graphik vom 16. Jahrhundert bis in die Gegenwart* (Dortmund, 1980); Michel Makarius, *Ruinen. Die gegenwärtige Vergangenheit* (Paris, 2004).
12 Makarius 2004 (see note 11), pp. 133–140.
13 Michael Glasmeier, "Verteidigung der Baustelle. Zur Situation," in *Üben. Essays zur Kunst* (Cologne, 2000) pp. 88–100.

Bialobrzeski's work runs counter to this rapidity. His photos, devoid of human beings, show us the precise condition of an urban present between ruin and redefinition, between the unpredetermined and the construction site. The old still exists, but the new has already been conceived. Infrastructure is discernible, but with no visible purpose. The absence of human activity or traffic makes the fallow land look like the stage for an unknown drama. Neon lights, signs, and traffic signals pervade these transitory spaces, yet we are unable to localize their meaning. What remains are large or marginal architectures as physiognomies of themselves. Marc Augé defines "non-places" as "two different but complementary realities: spaces constructed with reference to particular functions (traffic, transit, commerce, leisure), and the relationship the individual maintains to these spaces."[18] In the places that fascinate Bialobrzeski, both modalities, function and relationship, are taken to their limits or done away with altogether. One can only refer to them as "non-non-places"—places that are planned, but that simultaneously elude control.

Bialobrzeski's photographs provide no commentary; the scenes are marked by both an exaggerated lack of identity and a paradoxical self-referentiality. Yet these very qualities give these places of disintegration and parallel mutation—these precise moments between an undefined past and an undefined future—a clarity and momentousness that restores their dignity amid the diffusion. The photographer's circumspection, his measured pace, his care and preciseness of gaze transform these sites into conceptual spaces open to the art historical constants and experience of ruins discussed above; at the same time, however, they formulate a compositional dramaturgy in which the transitory itself appears as a deeply contemporary aesthetic. This quality shines in Bialobrzeski's work with a clarity of vision unique to the functionless, and is likewise manifested in the self-presentation of the photographed objects, causing us to initially forget their documentary aspect.

From the prose of unstable diffusion grows a poetics of glowing objects, one that, significantly, comes to particularly detailed expression in twilight. Bialobrzeski rejects the zone system of lighting developed by Ansel Adams in 1941, which went on to become the general photographic standard. Rather, his ideal light is dusk, another realm of the transitory and in-between. It is an illumination of possibility for spaces of possibility, a light that does not impose or call attention to itself, but that nonetheless allows objects to glow in their own significance. Above all, however, the twilight restores the power of self-assertion to artificial lighting and an inner reality to objects. Dusk defines through its indecisiveness. Painters from Adam Elsheimer to Jan Vermeer to René Magritte knew this when they strove to emphasize light as a source in itself rather than, as was usual, letting it glisten unlocalized throughout the picture.[19] In this way the apparition becomes concrete, earthly, and human. In the daylight, things are illuminated and robbed of their own radiant power; in the dark of night, they are disembodied as indistinct shadows contrasting with the more obvious demonstrations of light. Dusk, however, forms the backdrop for an exaggerated clarity, in which delicate surface articulations and the inherent power of specific lights can assert themselves.

In the light of dusk, the transitory can appear all the more luminous; it can extract itself from the question of location and become compelling for the photographer. In this special atmosphere, which Peter Bialobrzeski both seeks and intensifies, the self-sufficiency of diffuse urban spaces is realized as a specific statement. The transitory is articulated in the unrestrained reality of dusk. In these noiseless, concentrated photographs, we are lost in transitional spaces, transitional times, transitional light; we immerse ourselves in their atmospheric density, delicate precision, shining presence, absolute nowness—and know that there will be a future.

See for example Carl Aigner et al., eds., *Tomorrow For Ever. Architektur, Zeit, Photographie,* exh. cat. Museum Küppersmühle Sammlung Grothe (Duisburg, 1999).
See for example Gerhard Paul, *Bilder des Krieges. Krieg der Bilder. Die Visualisierung des modernen Krieges* (Paderborn, 2004).

16 Georg Simmel, "Die Ruine," in *Philosophische Kultur. Über das Abenteuer, die Geschlechter und die Krise der Moderne* (Berlin, 1983), pp. 111–112.
17 Ullrich Schwarz, "Entgrenzung der Architektur. Überlegungen zur Moderne," in Haus der Architektur Graz, ed., *100 % Stadt. Der Abschied vom Nicht-Städtischen* (Graz, 2003), p. 86.
18 Augé 1994 (see note 6), p. 110.

19 On Adam Elsheimer, see Reinhold Baumstark, ed., *Von neuen Sternen. Adam Elsheimers* Flucht nach Ägypten (Munich and Cologne, 2005). On Jan Vermeer, see for example Daniel Arasse, *Vermeers Ambition* (Dresden, 1996). On René Magritte's impressive painting *L'Empire des lumières* (1954) and its variations, see *René Magritte. Die Kunst der Konversation,* exh. cat. Kunstsammlung Nordrhein-Westfalen (Düsseldorf, 1996), pp. 130–134.

Von den Gegenwärtigkeiten des Nichtvorherbestimmten
Michael Glasmeier

Wir besitzen Bilder, Literaturen und explizite Theorien über den Raum, der uns umgibt und bestimmt. Folgen wir diesen Hinweisen, ist zu konstatieren, dass es dem heutigen, insbesondere dem urbanen zunehmend schlecht geht. Er isoliert und macht einsam, wirkt unlesbar, zersetzend und löst sich mit der Geschwindigkeit der Verkehrsmittel und Medien auf, so die Diagnose.[1] Mal zerdehnt sich der Raum, mal schrumpft er und folgt in seiner ständigen Bearbeitung und Neuordnung den Gesetzen eines weltweiten Primats der Ökonomie. Er präfiguriert gleichsam eine apokalyptische Vision auf Erden, in der wir als Simulanten unseren mickrigen Tätigkeiten nachgehen.[2]

Dieser Raum, der bedrohend als Megacity, postmodernisiert als Stadt und verödet als Dorf in Erscheinung tritt, will gebändigt sein, lebbar, historisiert und humanisiert werden, damit eine Zukunft nicht allzu katastrophal ausfällt. Auch dazu gibt es Bilder, Literaturen und explizite Theorien,[3] vor allem aber konkrete Ideen und Maßnahmen von Urbanisten und Architekten, die gepflegte Schneisen in die städtische Wildnis legen und Orientierung durch markante Prachtbauten inszenieren. So bleibt der Raum stetig in Bewegung, ohne sich allerdings zu konsolidieren wie das Paris eines Georges-Eugène Haussmann (1809–1891) oder zu rhythmisieren wie im Film *Berlin: Die Sinfonie der Großstadt* (1927) eines Walter Ruttmann (1887–1941). Stattdessen beherrschen permanente und offensichtlich anarchistische Neudefinitionen seine Funktionen, Aufgaben und Bedingungen. Das Alte hat sich dem Neuen bedingungslos zu fügen und dem Zeitgeist der globalen Ökonomie. Der urbane Raum als ein »Geflecht von beweglichen Elementen«[4] artikuliert sich diskontinuierlich in einer zu differenzierenden Gleichzeitigkeit von Heterotopien,[5] »Nicht-Orten«[6] und Palimpsesten[7] als Überlagerung von Funktionen.

Diese Haltlosigkeit des Urbanen, mit der das Wohnen selbst marginalisiert wird, lässt jede Frage nach Ästhetik politisch und jede Planung sozial werden. Den Künsten und Theorien wird es auf diese Weise leicht gemacht, allein durch das bloße Zeigen die Wunden, Narben und Unausweichlichkeiten zu benennen, zumal ein diätetischer Urbanismus selten in Sicht ist. So wie die Rockbands Ende der 1960er-Jahre in ihren Fernsehclips mindestens einmal auf Müllhalden auftraten, provoziert das Zusammentreffen des Undefinierten stetig und automatisch einen neuen Reichtum politischer Symbole, mit denen komplexe Wahrnehmungen zeichenhaft benannt werden. Der wabernde Raum erzeugt seine eigenen Bilder. Egal wohin das Kameraauge sich wenden mag, das Resultat wird politisch sein.

Das gilt natürlich auch für die Fotografien von Peter Bialobrzeski, zumal wenn sie sich mit *Lost in Transition*[8] dezidiert auf die benannte Diffusion urbaner Räume einlassen und in Sichtbarkeit überführen. Doch Bialobrzeski geht noch einen entscheidenden Schritt weiter: Seine Fotografien begnügen sich nicht mit der einfachen Erscheinung transitorischer Räume und dem beiläufigen Bannen eines gleichsam transitorischen Augenblicks – eine Doppelung, die den Effekt des Vagen und Unwahrscheinlichen steigert. Sie sind auch in erster Linie nicht als Spur, als Index des Wirklichen oder als Erinnerungsbilder zu lesen.[9] Alle diese Faktoren spielen zwar eine Rolle in den Aufnahmen, weil sie der Fotografie immanent sind, jedoch erfahre ich Bialobrzeskis Fotografien vielmehr als Behauptungen, die das Unwahrscheinliche der Wirklichkeit erhöhen und in Richtung Entschiedenheit weitertreiben. Sie reden nicht, sie sagen.

Vgl. die nützliche Zusammenstellung der entsprechenden Texte von René Descartes bis Paul Virilio in: *Raumtheorie. Grundlagentexte aus Philosophie und Kulturwissenschaften,* hrsg. von Jörg Dünne und Stephan Günzel, Frankfurt am Main 2006. Vgl. hierzu vor allem das Gesamtwerk des amerikanischen Science-Fiction-Autors Philip K. Dick (1928–1982) und die nach seinen Romanvorlagen gedrehten Filme *Blade Runner* (Ridley Scott, 1982), *Minority Report* (Steven Spielberg, 2002) und *A Scanner Darkly* (Richard Linklater, 2006).

3 Vgl. u. a. Marc Mer u. a., *Translokation. Der ver-rückte Ort. Kunst zwischen Architektur,* Wien 1994.

4 Michel de Certeau, *Kunst des Handelns,* Berlin 1988, S. 218.

5 Vgl. Michel Foucault, »Von anderen Räumen«, in: ders., *Dits et Ecrits. Schriften in vier Bänden,* Frankfurt am Main 2005, Bd. 4, S. 931–942.

6 Vgl. Marc Augé, *Orte und Nicht-Orte. Vorüberlegungen zu einer Ethnologie der Einsamkeit,* Frankfurt am Main 1994.

7 Der rhetorische Begriff des Palimpsests wird im Moment vor allem von der Literatur- und der Kulturwissenschaft genutzt. Vgl. zur näheren Bestimmung u. a. Gérard Genette, *Palimpseste. Die Literatur auf zweiter Stufe,* Frankfurt am Main 1993.

8 Der Titel spielt überdeutlich auf den Film *Lost in Translation* (2003) von Sofia Coppola an. Dieser handelt von den typischen Erfahrungen einer grundsätzlich unübersetzbaren Fremdheit, in der zwei amerikanische Tokio-Reisende (Bill Murray und Scarlett Johansson) in einem Hotel für eine gewisse Zeit zusammenfinden.

9 Vgl. Philippe Dubois, *Der fotografische Akt. Versuch über ein theoretisches Dispositiv,* Amsterdam und Dresden 1998.

Bialobrzeski fotografiert das Transitorische weniger als Dokumentarist. Mit seiner Plattenkamera, die er zu den unmöglichsten Orten auf diesem Planeten mitschleppt, gelingt es ihm, Räume des Übergangs als grandiose in Sichtbarkeit zu überführen. Er fotografiert urbane Wüsteneien wie in Szene gesetzte Festarchitekturen einer Moderne, die sich selbst feiern und repräsentieren will. Dieser Widerspruch führt zu Bildern der präzisen Ordnung und kompositorischen Dichte und damit zu einer konzentrierten fotografischen Anteilnahme am Diffusen, die aufgrund methodischer Unangemessenheit eine Dauer der Betrachtung verlangt, die im kompletten Gegensatz steht zur tatsächlichen Zeit, die wir an diesen Orten zu verbringen gewillt sind. Diese geht gegen null; denn der Witz des Transitorischen liegt in vorgeblicher Bedeutungslosigkeit und herrschaftsloser Unschärfe, die weder zum Verweilen noch zur genaueren Betrachtung einladen.

10 Vgl. u. a. *Das Capriccio als Kunstprinzip. Zur Vorgeschichte der Moderne von Arcimboldo und Callot bis Tiepolo und Goya,* hrsg. von Ekkehard Mai, Ausst.-Kat. Wallraf-Richartz-Museum, Köln 1996; *Vedute, architektonisches Capriccio und Landschaft in der venezianischen Graphik des 18. Jahrhunderts,* hrsg. von Peter Dreyer, Ausst.-Kat. Staatliche Museen Preußischer Kulturbesitz, Berlin 1985; Norbert Miller, *Archäologie des Traums. Versuch über Giovanni Battista Piranesi,* München und Wien 1978; Annelie Lütgens, *Giovanni Battista Piranesi. Bilder von Orten und Räumen,* Ausst.-Kat. Hamburger Kunsthalle, Hamburg 1994.

Aus kunsthistorischer Sicht hat es vor allem in der Zeitspanne vom Manierismus bis in die Romantik immer wieder Versuche gegeben, transitorische Räume aufzuladen und in malerischen und zeichnerischen Denkbildern zu verewigen. Auch hier stand ein Modell der Wirklichkeit – ein Auferstanden aus den Ruinen der Antike – hinter der Bildfindung der Capriccios und Veduten, die vor allem mit Giovanni Battista Piranesi schließlich ins freie Reich der Fantasie überwechselten.[10] Diese Ruinenfaszination, bei der die Vorbildhaftigkeit der Antike, die Leidenschaft für das Bizarre und der Vanitasgedanke gleichermaßen eine Rolle spielen, führte zu Bildern, die aus dem tatsächlichen Formenreichtum des architektonisch Kaputten künstlerische Strategien entwickelten und zugleich als Allegorien der Geschichte gelesen werden können.[11] Mit der deutschen Romantik wird dann vor allem die verfallene gotische Kathedrale zum symbolischen Ort eines transzendentalen Naturmodels von Architektur.[12] Parallel dazu entwickelt sich in der Kunst mit dem Sujet des Turmbaus zu Babel eine Baustellenfaszination, die, allerdings weniger fruchtbar, nur gelegentlich aufglomm und erst im 19. Jahrhundert vor allem mit Adolph Menzel zu ihrem Thema fand.[13] Mit der Frühgeschichte der Fotografie sollten diese Motive nahtlos eine Fortsetzung finden, die bis heute andauert. War die fotografische Ruinenfaszination im 19. Jahrhundert vor allem archäologisch motiviert,[14] so wechselte sie mit den beiden Weltkriegen des 20. Jahrhunderts in das Dokumentarische über, um hier Meisterwerke der Anteil nehmenden Erfassung von Zerstörung und Gewalt hervorzubringen.[15]

Mit dieser äußerst verknappten Zusammenfassung möchte ich betonen, dass alle diese bildhistorischen Elemente – das Dokumentarische der Vedute und der Fotografie, das Bizarre des Capriccios, Vanitas und archäologische Bestandsaufnahme – selbstverständlich in den Fotografien Bialobrzeskis anwesend sind. Sie sind der Basso continuo, der automatisch dann einsetzt, wenn wir unseren Blick auf das Transitorische justieren, oder wie es der Soziologe Georg Simmel in seinem Essay über die ästhetische Erfahrung der Ruine formuliert: »Die Ruine schafft die gegenwärtige Form eines vergangenen Lebens, nicht nach seinen Inhalten oder Resten, sondern nach seiner Vergangenheit als solche. [...] So lösen Zweck und Zufall, Natur und Geist, Vergangenheit und Gegenwart an diesem Punkte die Spannung ihrer Gegensätze, oder vielmehr, diese Spannung bewahrend, führen sie dennoch zu einer Einheit des äußeren Bildes, der inneren Wirkung. Es ist, als müsste ein Stück des Daseins erst verfallen, um gegen alle, von allen Windrichtungen der Gegenwart herkommenden Strömungen und Mächte so widerstandslos zu werden.«[16]

Simmels Gegenwärtigkeit misst sich an der Dauerhaftigkeit von Ruinen und beschwört gleichzeitig jene Einheit, in der sich mit der Sichtbarkeit die kontrapunktischen Elemente im Bild auflösen. Doch die Wirklichkeit der letzten fünfzig Jahre zeitigt eine Gegenwart, der das Romantische und Historische fremd geworden ist. Die Gegenwart selbst ist ruinös. Die stabilen Größen des Urbanen mutieren mit der Dominanz des Ökonomischen und eines Funktionswandels des Arbeitsbegriffs in »Räume des Nichtvorherbestimmten«.[17] Fabrikanlagen können zu Dienstleistungs- oder Kreativzentren, Slums zu Autobahnkreuzen, Häfen zu Containerparks, Bahnhöfe zu Shopping Malls, Postämter zu Museen transformiert oder schließlich ganz abgebrochen werden. Die Bedingungen der Globalisierung schließen hier keinen Funktionswechsel, kein Palimpsest, keine Destruktion aus. Das alles geschieht in einer extremen und oft bedenkenlosen Schnelligkeit, die auch die Manifestationen jüngster Architekturen nicht ungeschoren davonkommen lässt. Angesichts dieser pulsierenden Gegenwarten, in denen die urbanen Konstanten permanent zur Disposition stehen, erscheint ein Beharren auf die Erkenntniskraft von Vergangenheiten als sentimentale Geste.

11 Vgl. Jeannot Simmen, *Ruinen-Faszination in der Graphik vom 16. Jahrhundert bis zur Gegenwart,* Dortmund 1980; Michel Makarius, *Ruinen. Die gegenwärtige Vergangenheit,* Paris 2004.
12 Vgl. Makarius 2004 (wie Anm. 11), S. 133 ff.
13 Vgl. Michael Glasmeier, »Verteidigung der Baustelle. Zur Situation«, in: ders., *Üben. Essays zur Kunst,* Köln 2000, S. 88–100.

Bialobrzeski arbeitet der Schnelligkeit entgegen. Seine menschenleeren Fotos zeigen uns exakt jenen Zustand einer urbanen Gegenwart zwischen Ruine und Neudefinition, zwischen Nichtvorherbestimmtsein und Baustelle. Das Alte ist noch da, aber das Neue schon gedacht. Infrastruktur wird zwar ablesbar, aber ohne ein Ziel erscheinen zu lassen. Das Fehlen von menschlichen Tätigkeiten und Verkehr lässt Brachland wie eine Bühne sichtbar werden, auf der nicht ausgemacht ist, was gespielt wird. Neonzeichen, Beschriftungen und Verkehrssymbole durchziehen diese transitorischen Orte, ohne dass wir den Sinn lokalisieren könnten. Was bleibt, sind große oder marginale Architekturen als Physiognomien ihrer selbst. Marc Augé definiert »Nicht-Orte« als »zwei verschiedene, jedoch einander ergänzende Realitäten: Räume, die in Bezug auf bestimmte Zwecke (Verkehr, Transit, Handel, Freizeit) konstruiert sind, und die Beziehung, die das Individuum zu diesen Räumen unterhält«.[18] Beide Modalitäten, Zweck und Beziehung, finden sich in den Orten, die Bialobrzeski faszinieren, an ihre Grenzen gebracht oder gänzlich aufgehoben. Wir müssten hier von »Nicht-Nicht-Orten« sprechen, von Orten, die geplant und doch gleichzeitig außer Kontrolle geraten sind.

Diese Orte der Auslöschung und parallelen Veränderung, der exakten Gegenwart zwischen unbestimmter Vergangenheit und unbestimmter Zukunft erlangen durch das Fehlen jeglichen Kommentars in den Fotografien Bialobrzeskis, durch ihre überdeutliche Selbstlosigkeit und paradoxe Selbstreflexivität eine Klarheit und Prägnanz, die ihnen ihre Würde im Diffusen zurückschenkt. Die Besonnenheit des Fotografen, seine Langsamkeit, Sorgfalt und Präzision des Blicks transformieren sie in Denkräume, die offen sind für die schon benannten bildhistorischen Konstanten und Ruinenerfahrungen, gleichzeitig aber eine kompositorische Dramaturgie formulieren, mit der das Transitorische selbst als zutiefst zeitgenössische Ästhetik sichtbar wird. Diese glänzt bei Bialobrzeski in einer Klarsichtigkeit, die dem Funktionslosen eigen ist, sowie durch die Art und Weise, wie die Objekte sich auf diesen Fotografien repräsentieren und das Dokumentarische zunächst vergessen machen.

Aus der Prosa des haltlos Diffusen erwächst eine Poetik der leuchtenden Objekte, die sich bezeichnenderweise im Zwielicht besonders detailliert umsetzt. Bialobrzeski, der das von Ansel Adams 1941 entwickelte und inzwischen allgemein zum fotografischen Standard erhobene Zonensystem für die Belichtung negiert, findet sein ideales Licht in der Dämmerung, also auch wieder in einem transitorischen Zwischenreich. Es ist ein Möglichkeitslicht für Möglichkeitsräume, ein Licht, das sich nicht aufdrängt, das nicht im Mittelpunkt stehen will und doch den Dingen erlaubt, in ihrer eigenen Bedeutung zu strahlen. Vor allem aber gibt die Dämmerung den künstlichen Lichtern die Kraft der Selbstbehauptung und den Objekten ihre innere Wirklichkeit zurück. Die Dämmerung präzisiert durch Unentschiedenheit. Das wussten auch schon die Maler von Adam Elsheimer über Jan Vermeer bis zu René Magritte, wenn es ihnen darum ging, das Licht nicht wie üblich unlokalisierbar ins Bild prasseln zu lassen, sondern es selbst als Quelle zu zentrieren.[19] Damit wird die Erscheinung konkret, irdisch und menschlich. Während sich die Dinge in Tageshelle beleuchtet und ihrer eigenen Strahlungskraft beraubt und im Dunkel der Nacht als vage Schatten im Kontrast mit vordergründigen Lichtdemonstrationen entkörperlicht finden, erlaubt es die Dämmerung, eine Überdeutlichkeit zu inszenieren, in der sich das Feingliedrige der Oberflächen und die Kraft der Leuchtkörper aus sich selbst heraus beweisen können.

Im Licht der Dämmerung kann das Transitorische umso illustrer erscheinen, sich herausschälen aus der Standortfrage und für den Fotografen verbindlich machen. In dieser besonderen Atmosphäre, die Peter Bialobrzeski sucht und bestätigt, ereignet sich die Selbstgenügsamkeit des urban Diffusen als ein bestimmtes Sagen. Das Transitorische artikuliert sich in der ungebremsten Wirklichkeitskraft der Dämmerung. Wir sehen in diesen stillen, konzentrierten Fotografien Verlorenheit in Übergangsräumen, Übergangszeiten, Übergangslichtern, vertiefen uns in ihre atmosphärische Dichte, feine Genauigkeit, strahlende Präsenz, absolute Gegenwärtigkeit – und wissen, dass es eine Zukunft geben wird.

16 Georg Simmel, »Die Ruine«, in: ders., *Philosophische Kultur. Über das Abenteuer, die Geschlechter und die Krise der Moderne,* Berlin 1983, S. 106–112, hier S. 111 f.

17 Ullrich Schwarz, »Entgrenzung der Architektur. Überlegungen zur Moderne«, in: *100 % Stadt. Der Abschied vom Nicht-Städtischen,* hrsg. vom Haus der Architektur Graz, Graz 2003, S. 79–91, hier S. 86.

18 Augé 1994 (wie Anm. 6), S. 110.

Vgl. u. a. *Tomorrow For Ever. Architektur, Zeit, Photographie,* hrsg. von Carl Aigner u. a., Ausst.-Kat. Museum Küppersmühle Sammlung Grothe, Duisburg 1999.
Vgl. u. a. Gerhard Paul, *Bilder des Krieges. Krieg der Bilder. Die Visualisierung des modernen Krieges,* Paderborn 2004.

19 Zu Adam Elsheimer vgl. Reinhold Baumstark (Hrsg.), *Von neuen Sternen. Adam Elsheimers »Flucht nach Ägypten«,* München und Köln 2005; zu Jan Vermeer u. a. Daniel Arasse, *Vermeers Ambition,* Dresden 1996; sowie zu René Magrittes eindrucksvollem Gemälde *L'Empire des lumières* (1954) und seinen Varianten *René Magritte. Die Kunst der Konversation,* Ausst.-Kat. Kunstsammlung Nordrhein-Westfalen, Düsseldorf 1996, S. 130 ff.

Transition 01

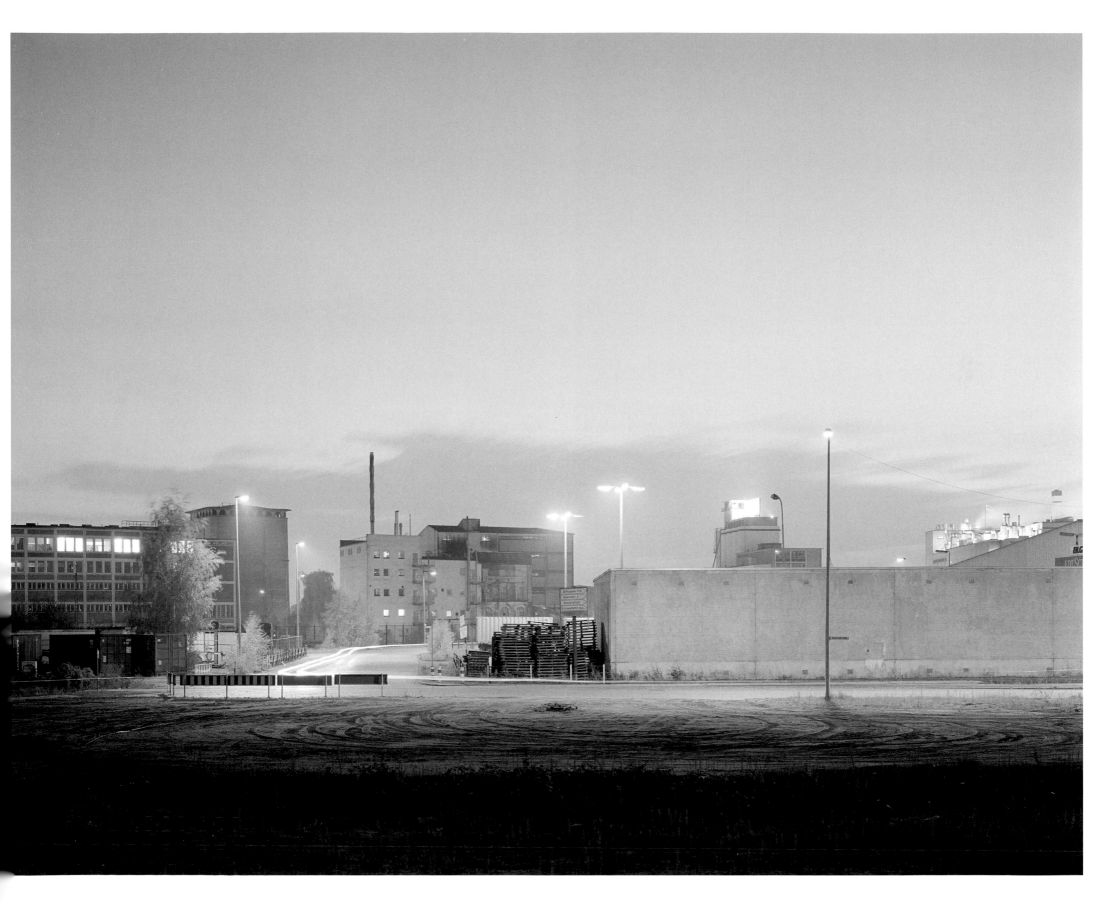

Transition 02

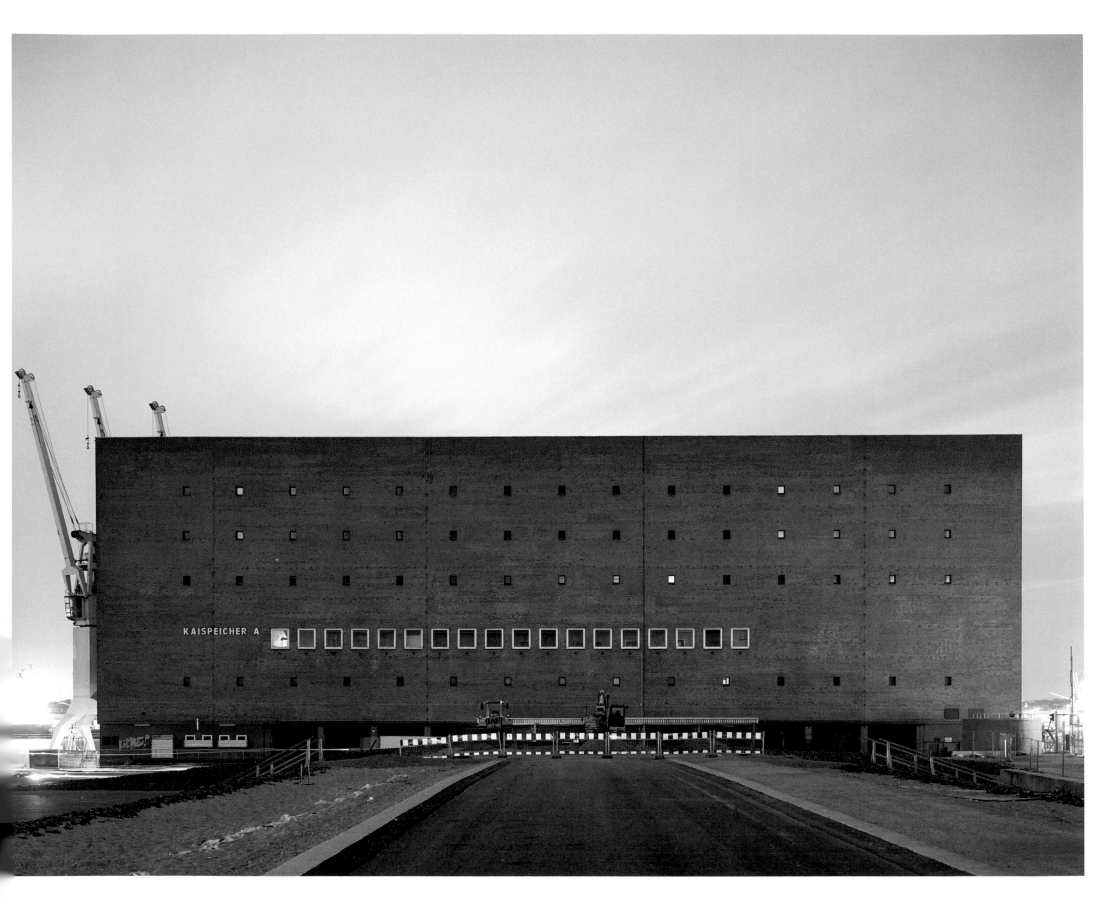

Transition 03

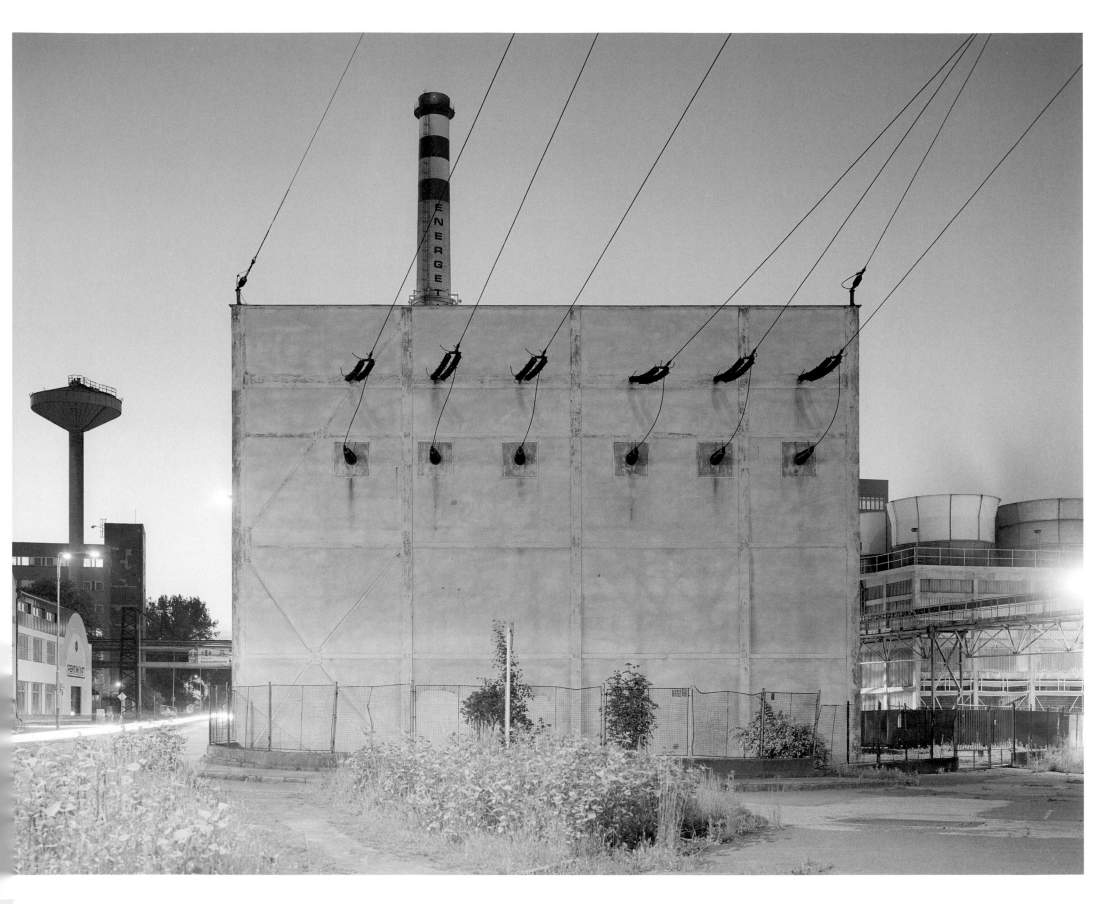

Transition 04

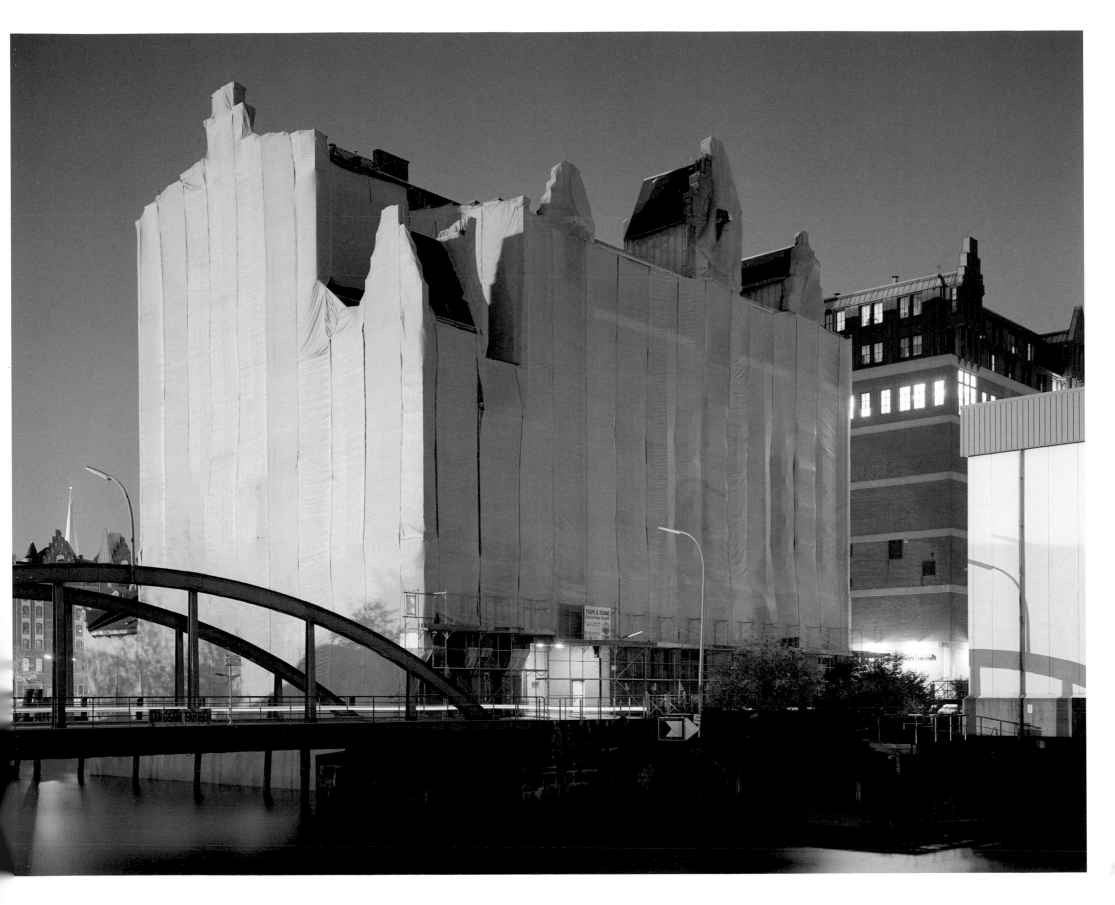

Transition 05

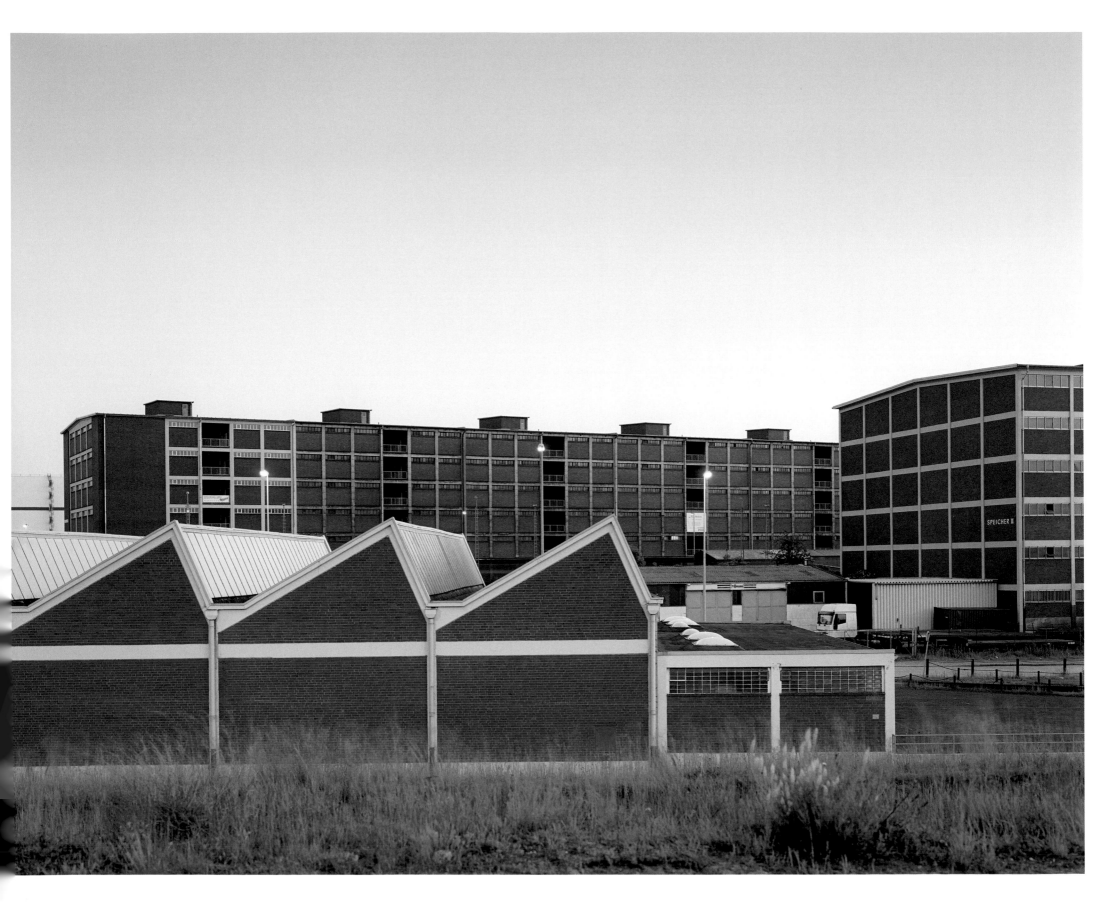

Transition 06

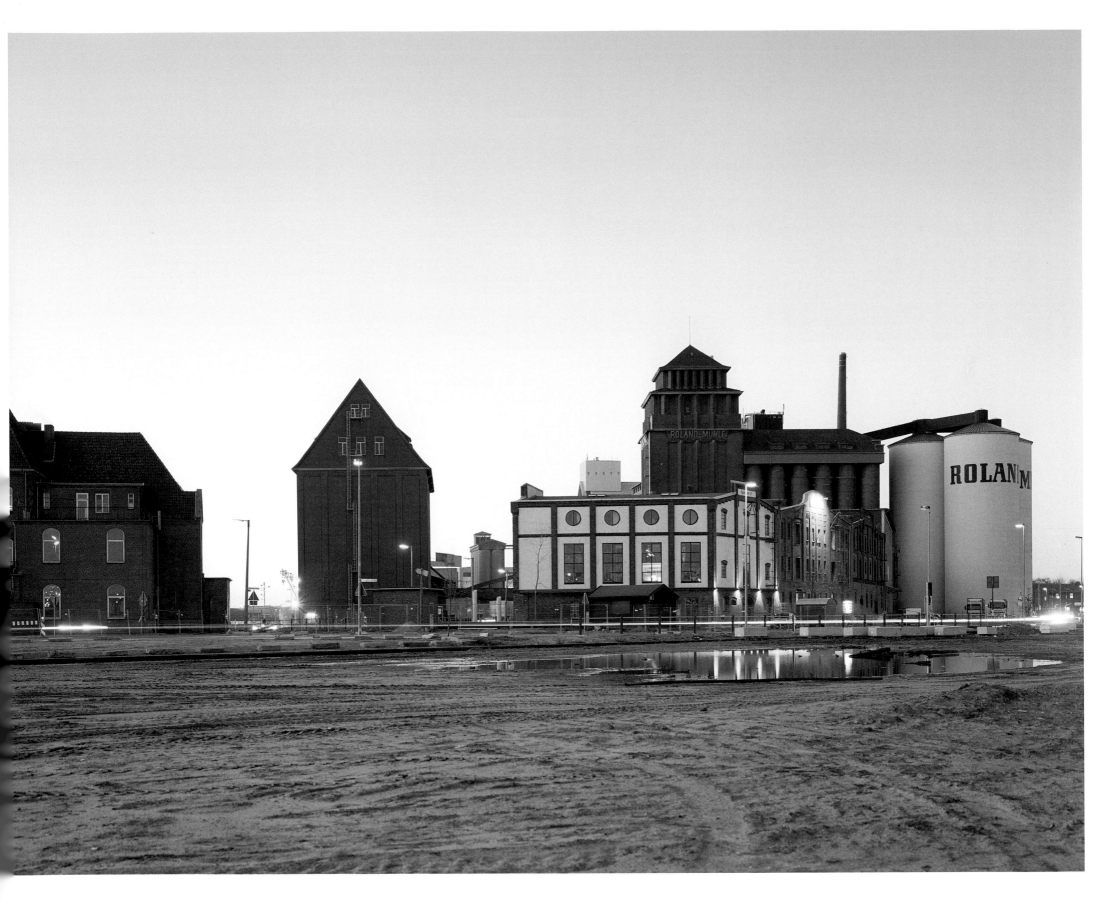

Transition 07

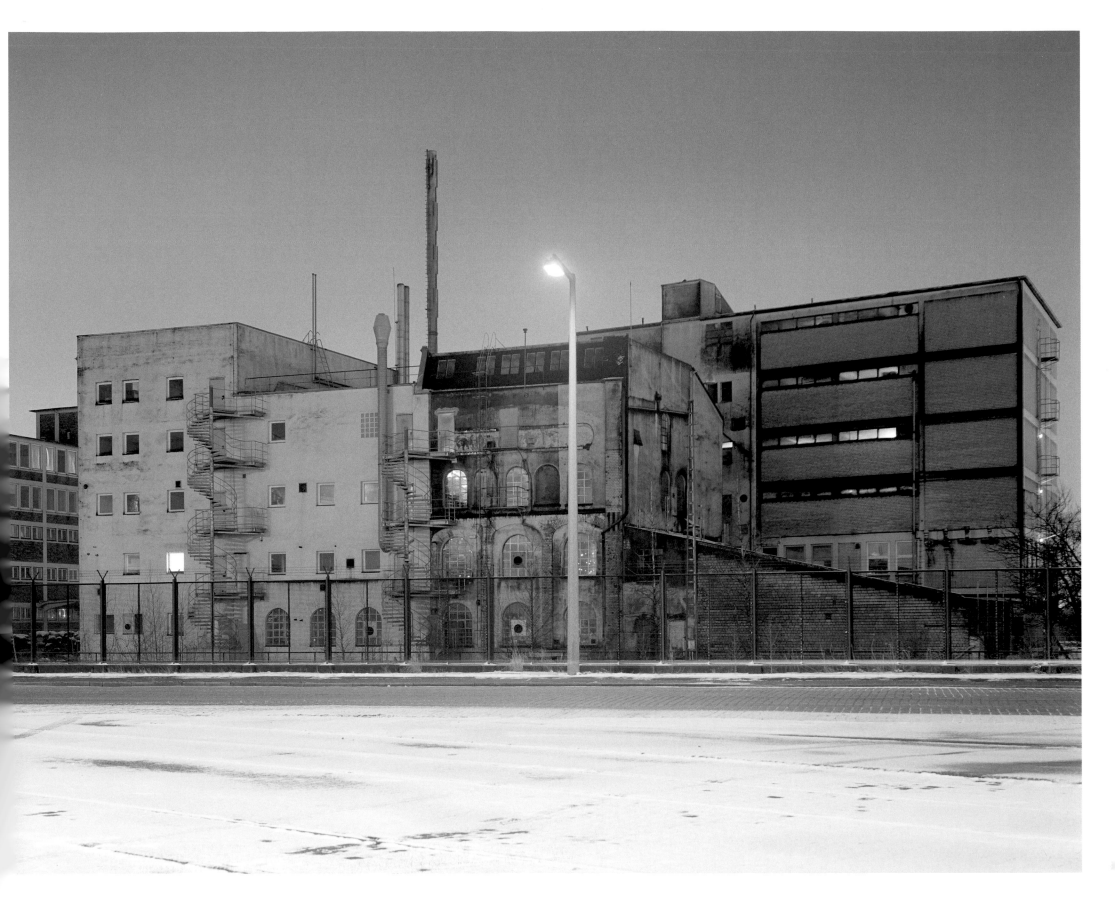

Transition 08

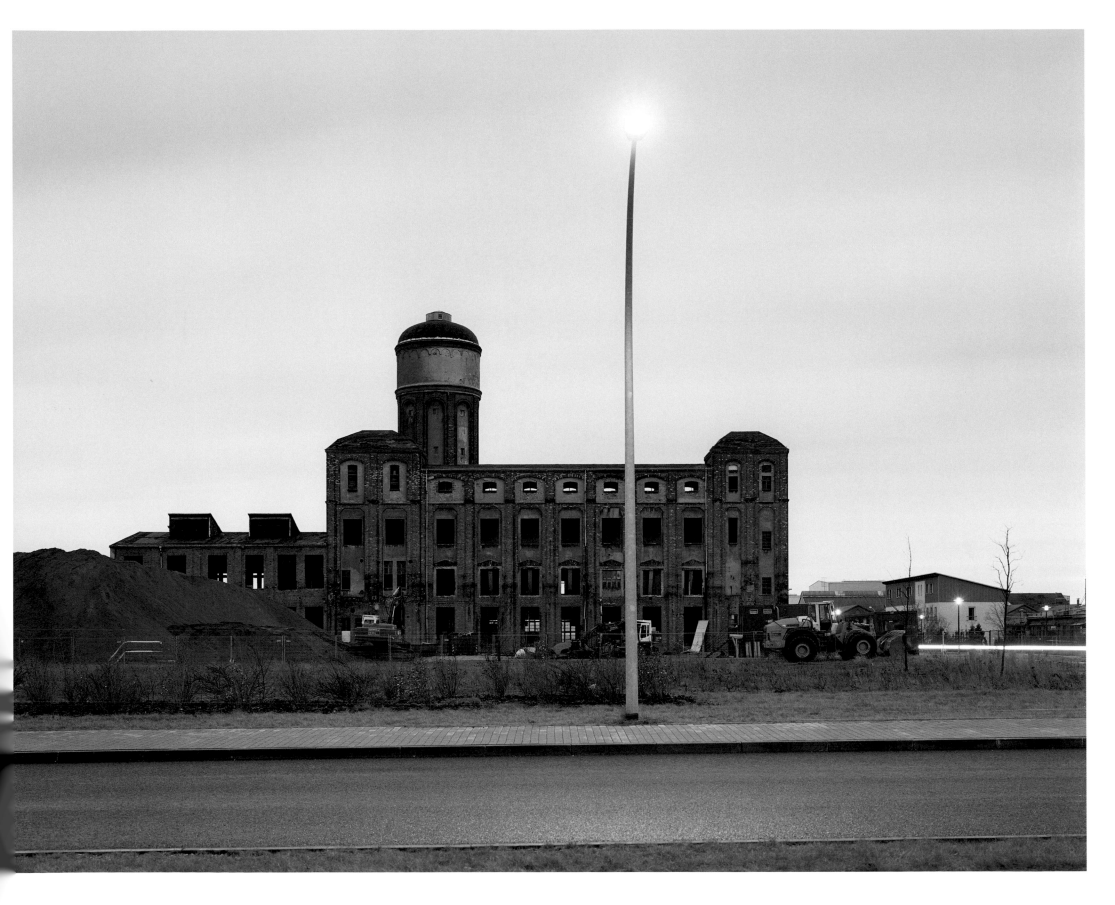

Transition 09

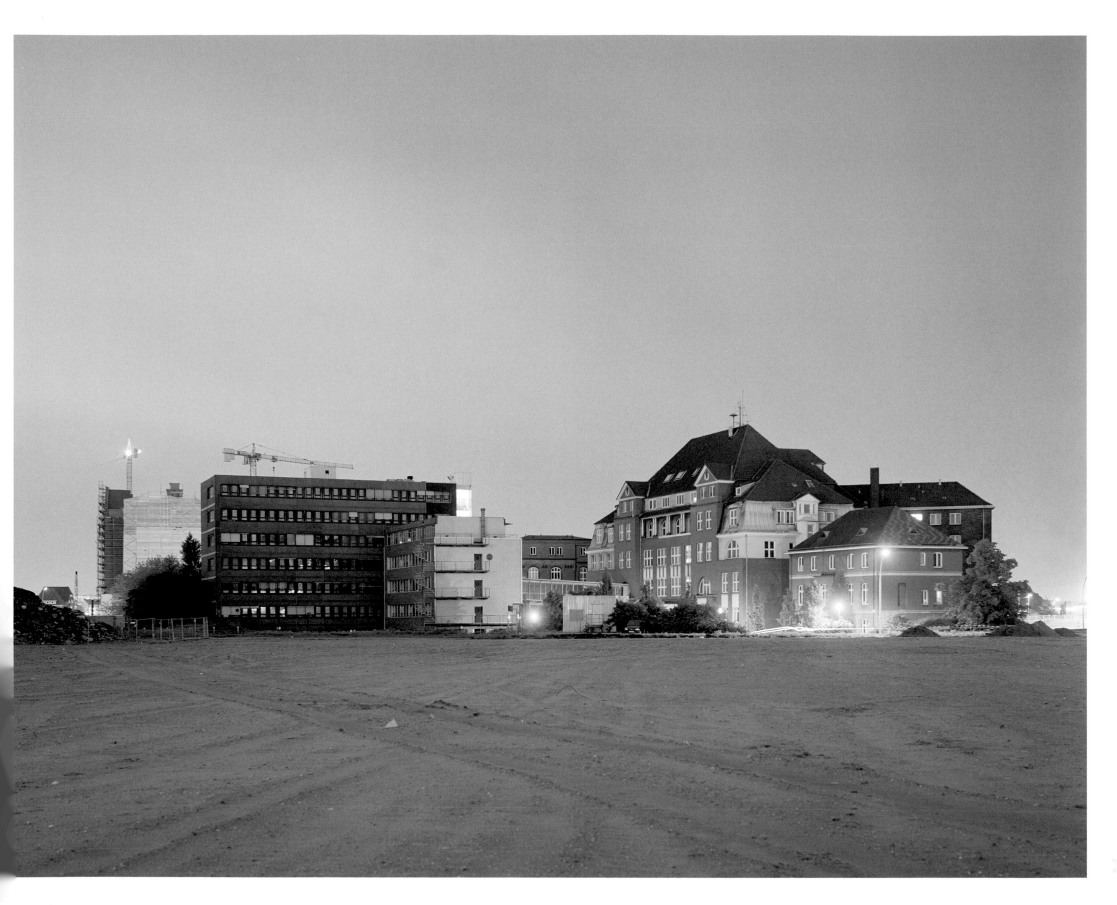

Transition 10

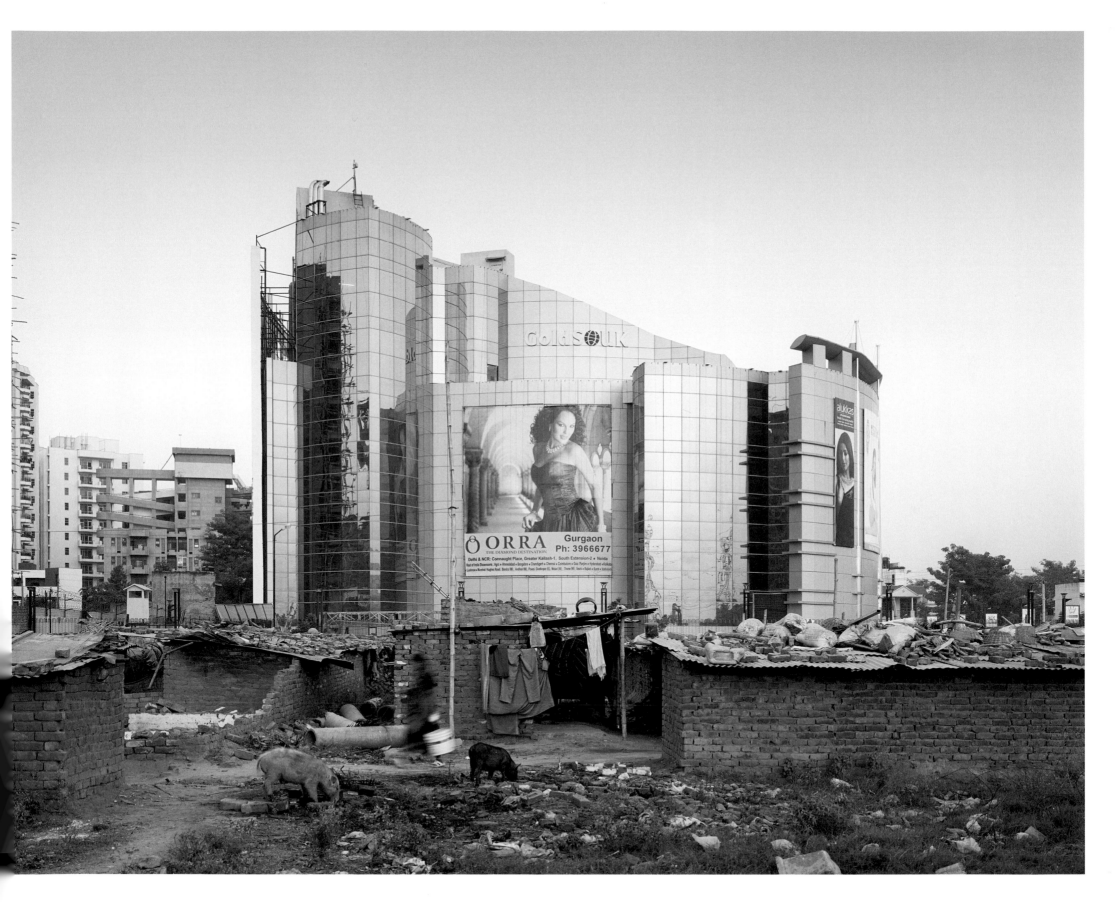

Transition 11

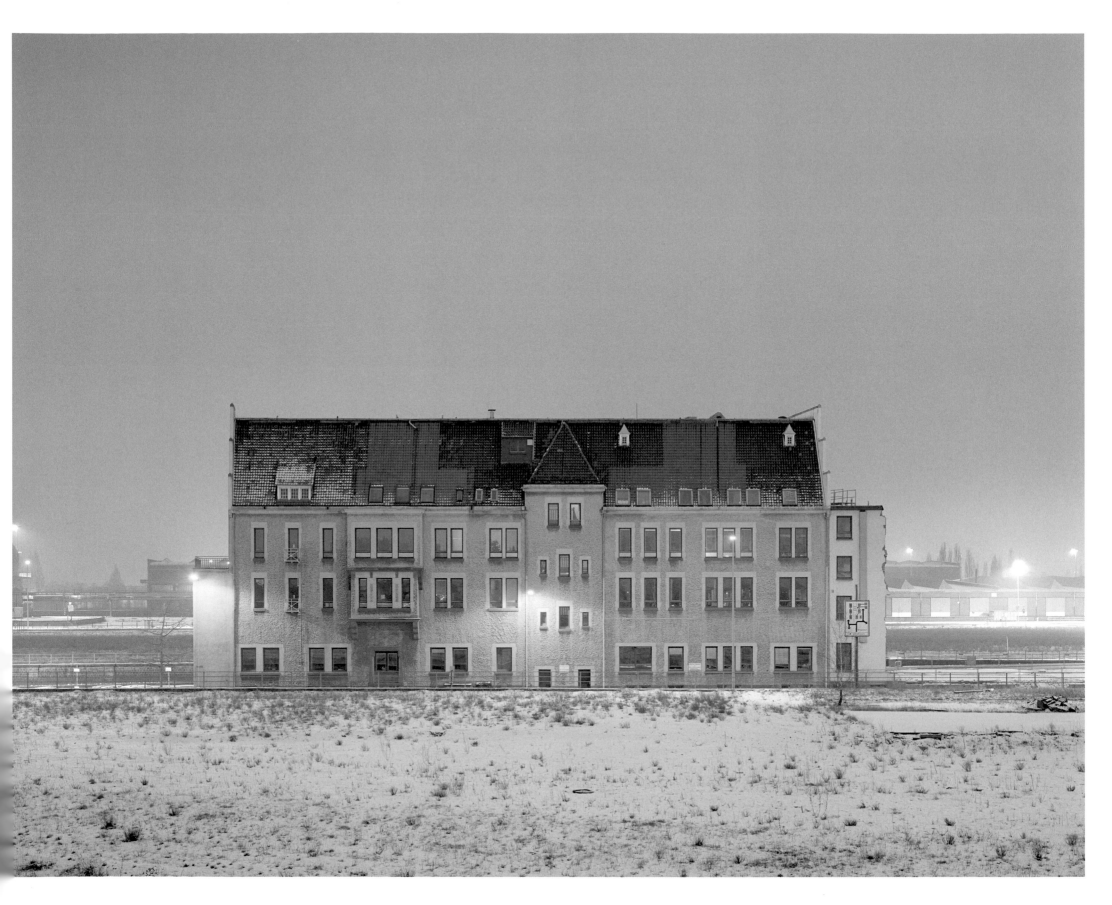

Transition 12

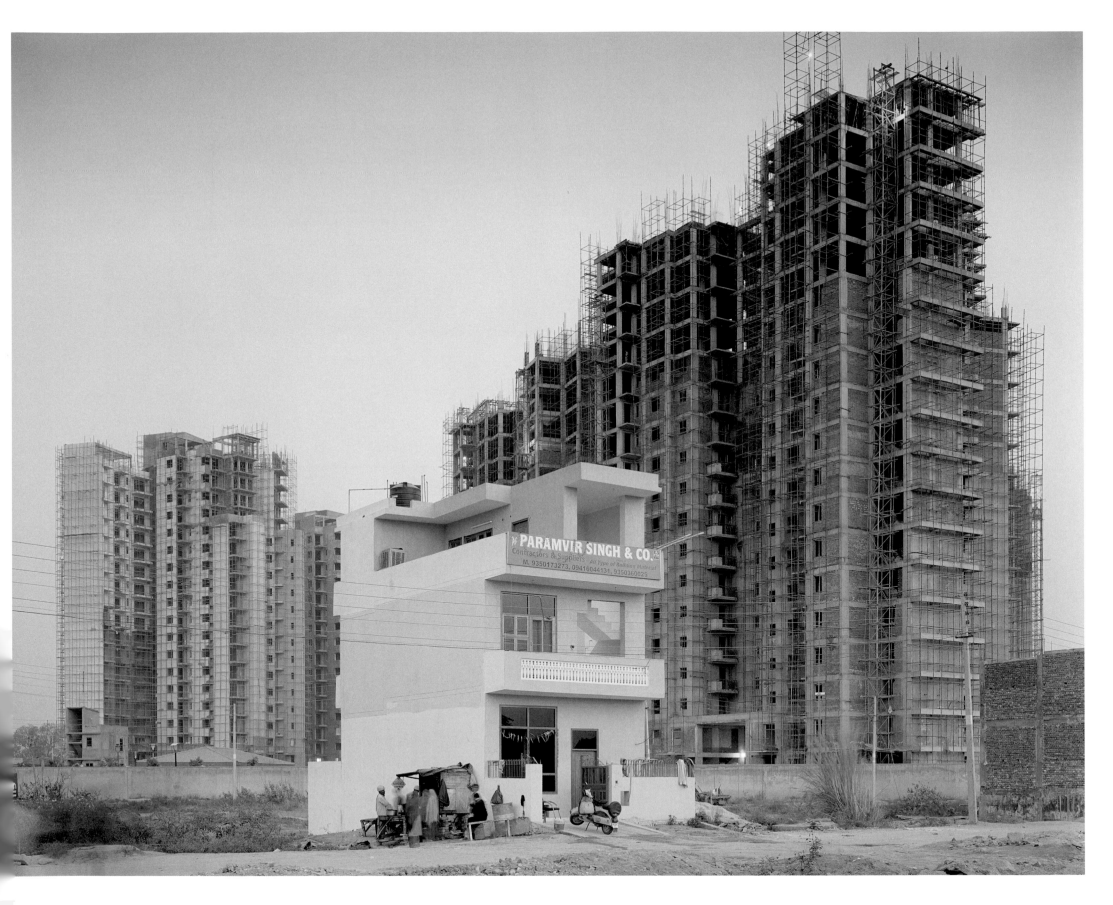

Transition 13

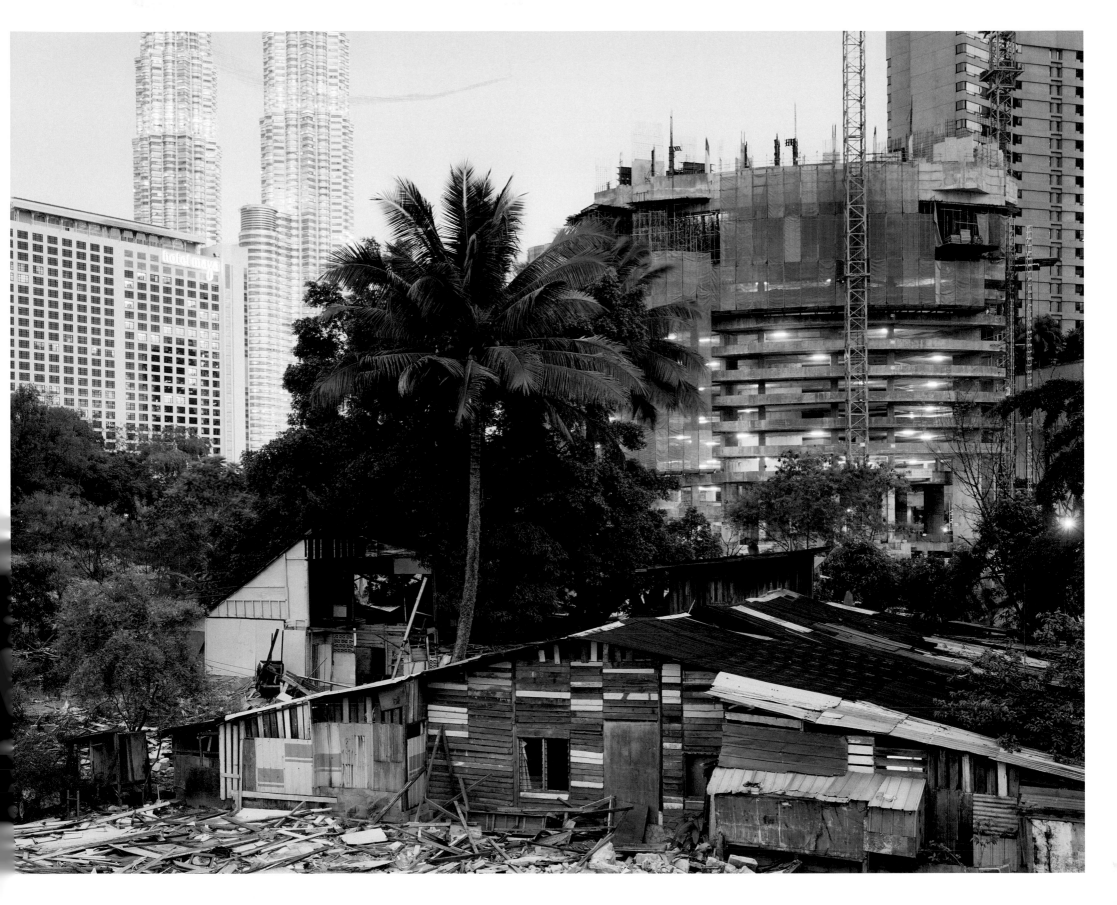

Transition 14

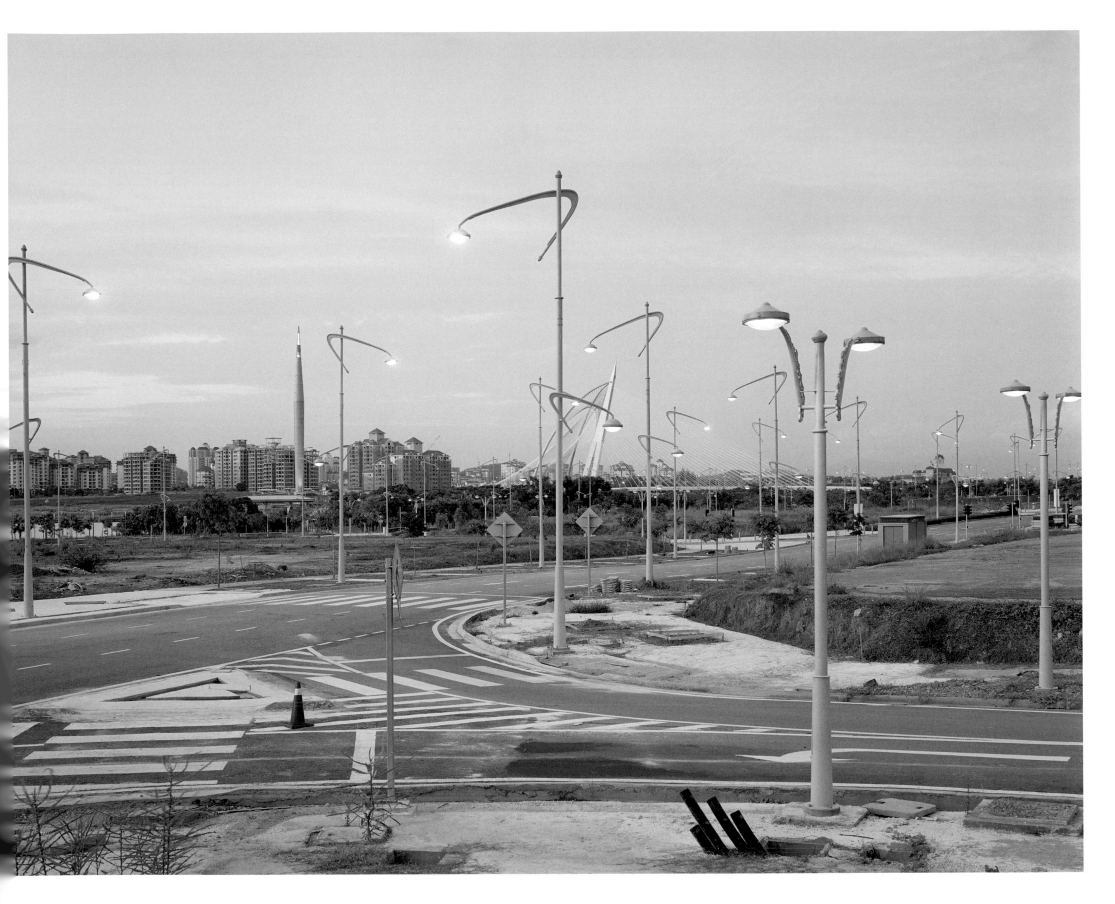

Transition 15

.

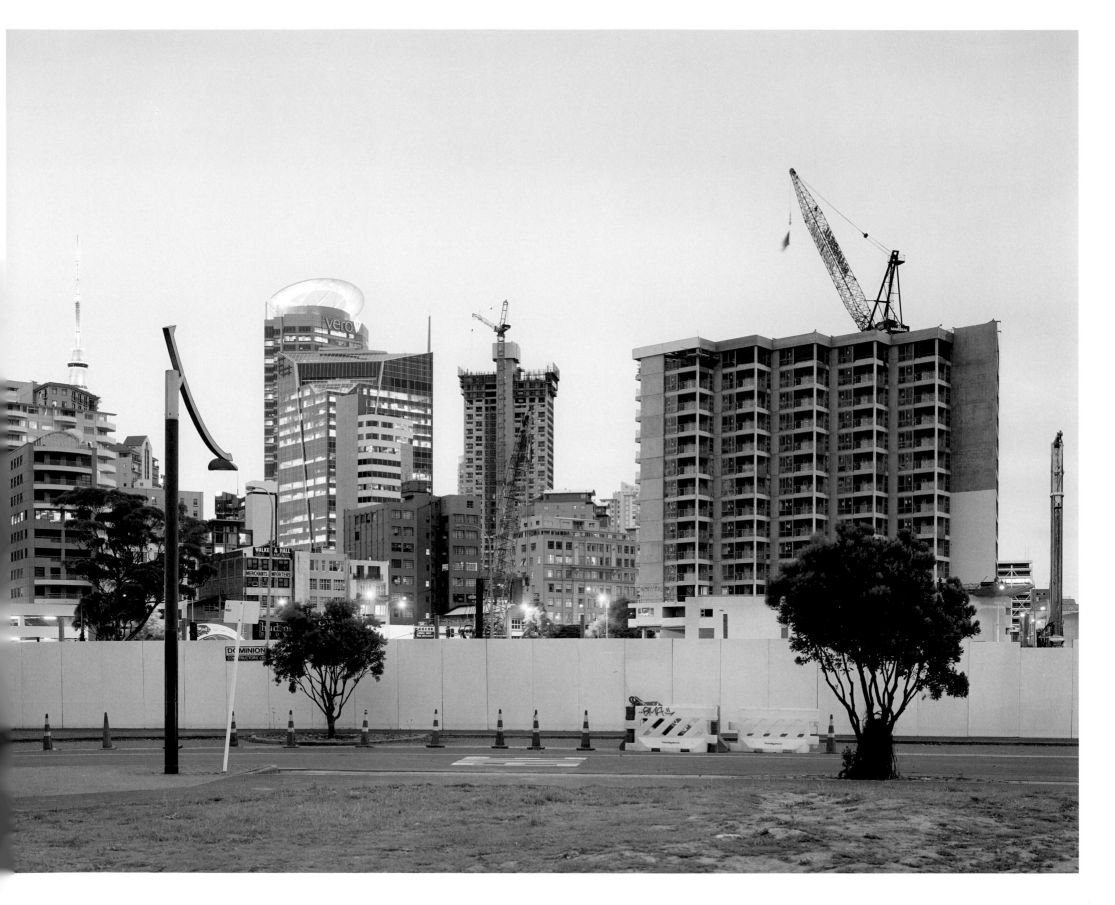

Transition 16

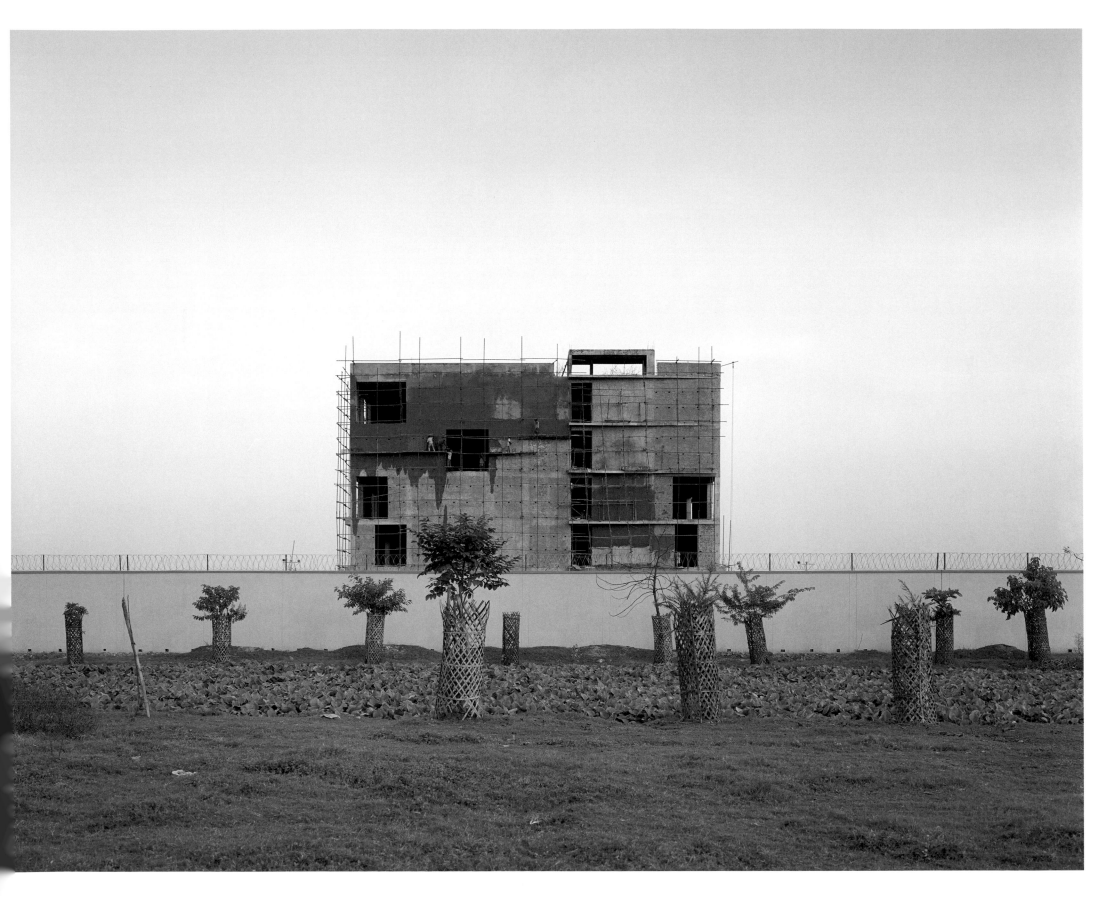

Transition 17

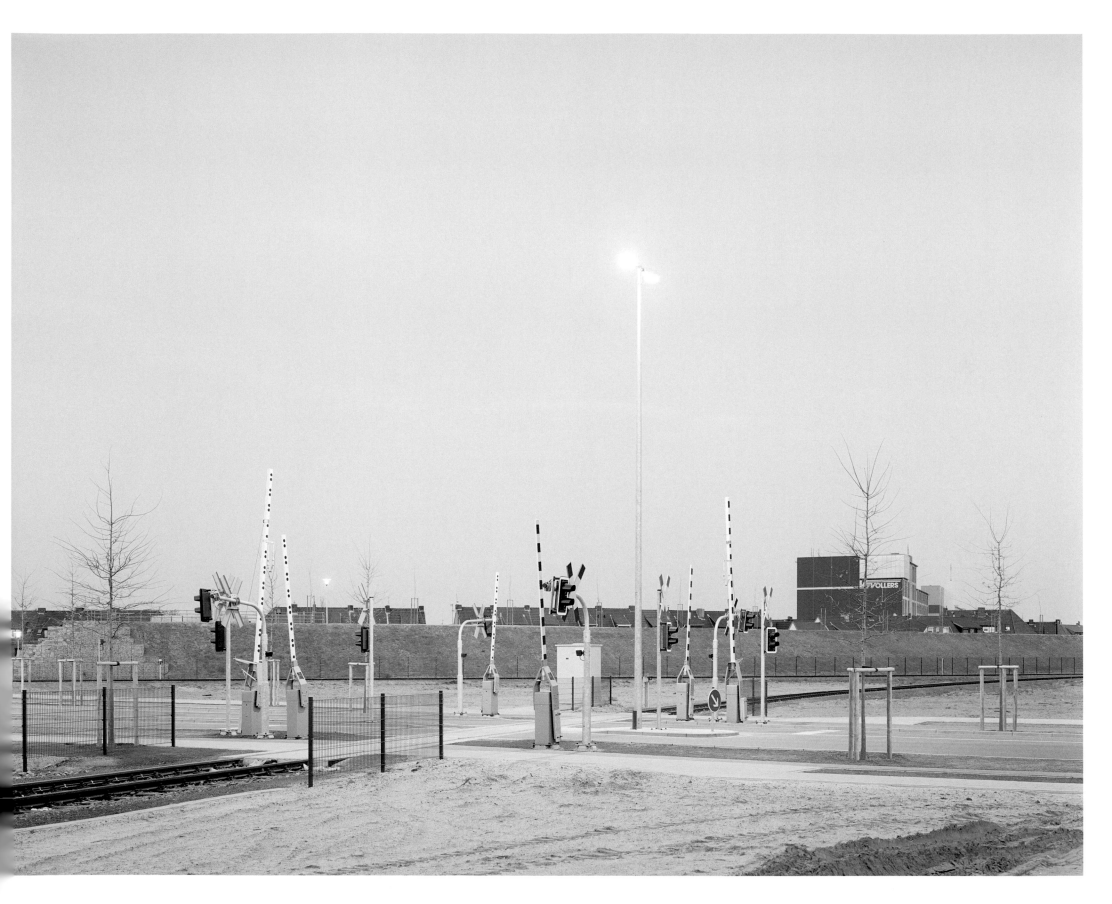

Transition 18

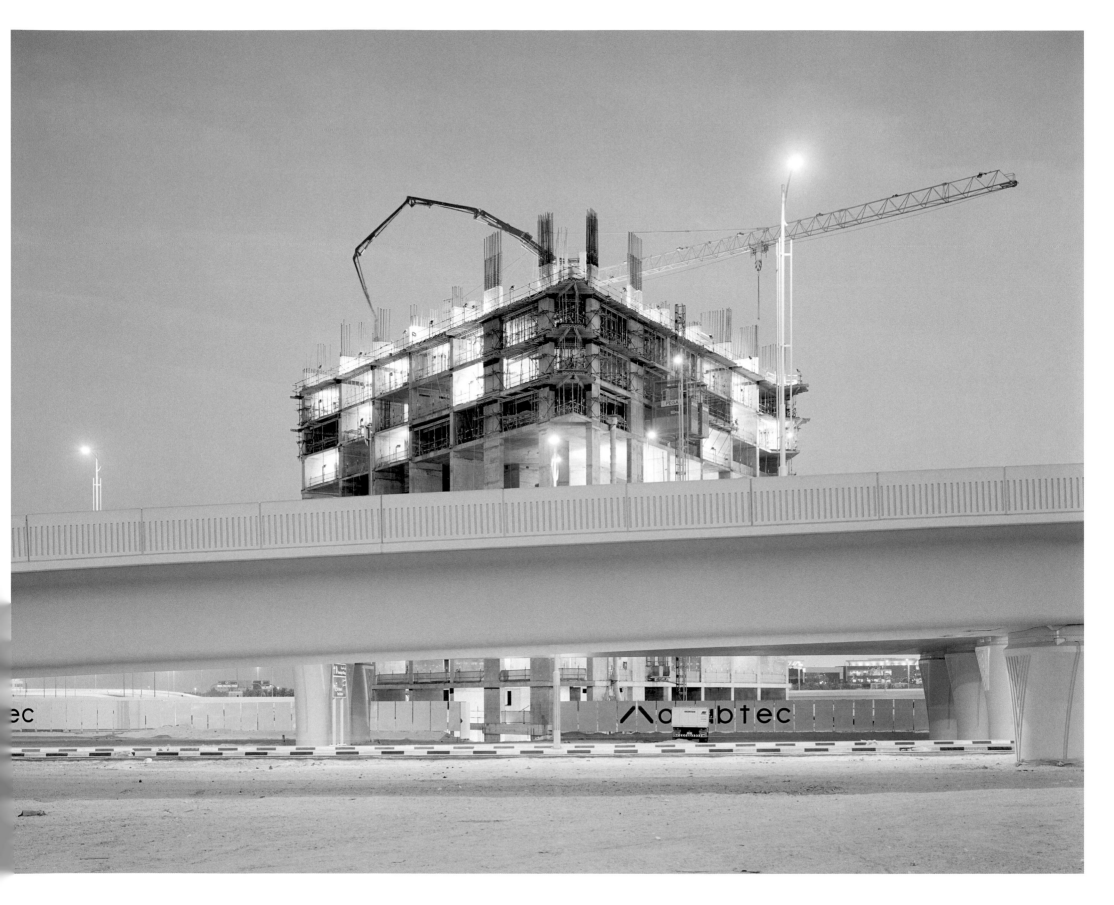

Transition 19

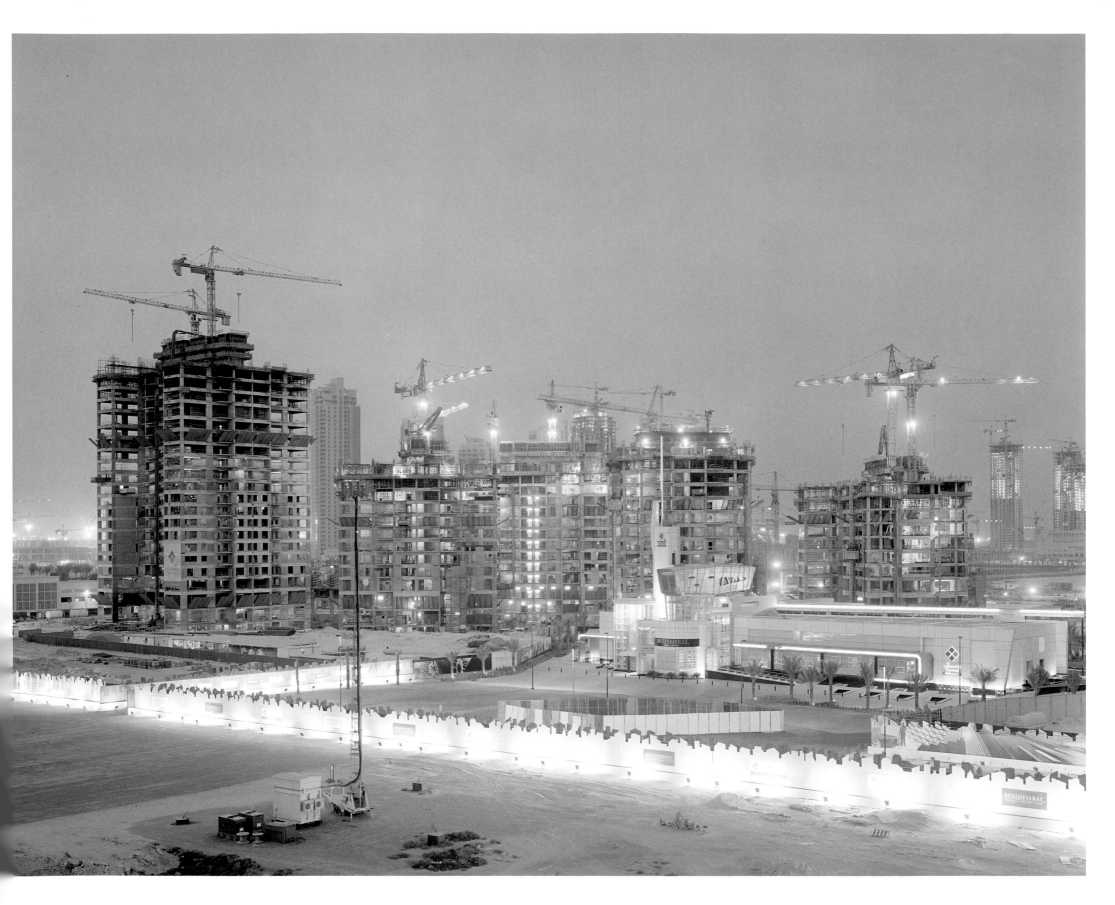

Transition 20

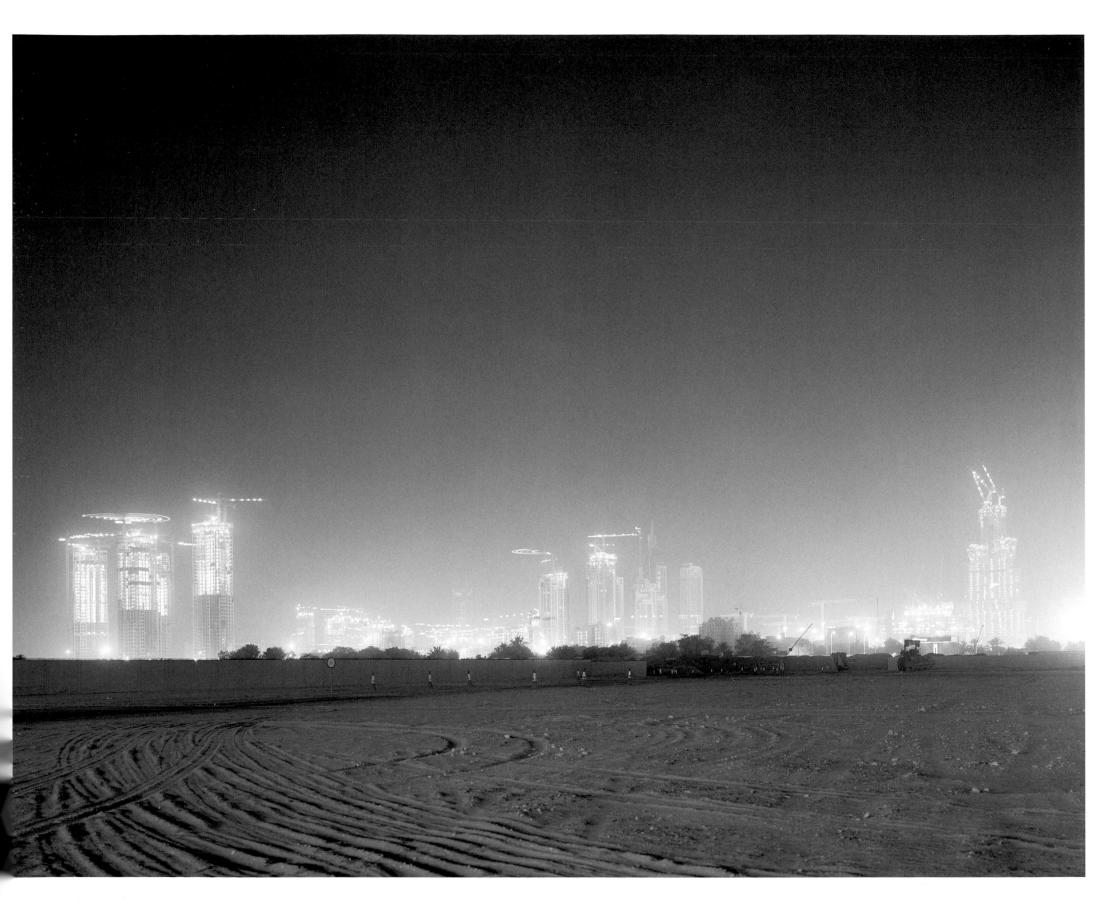

Transition 21

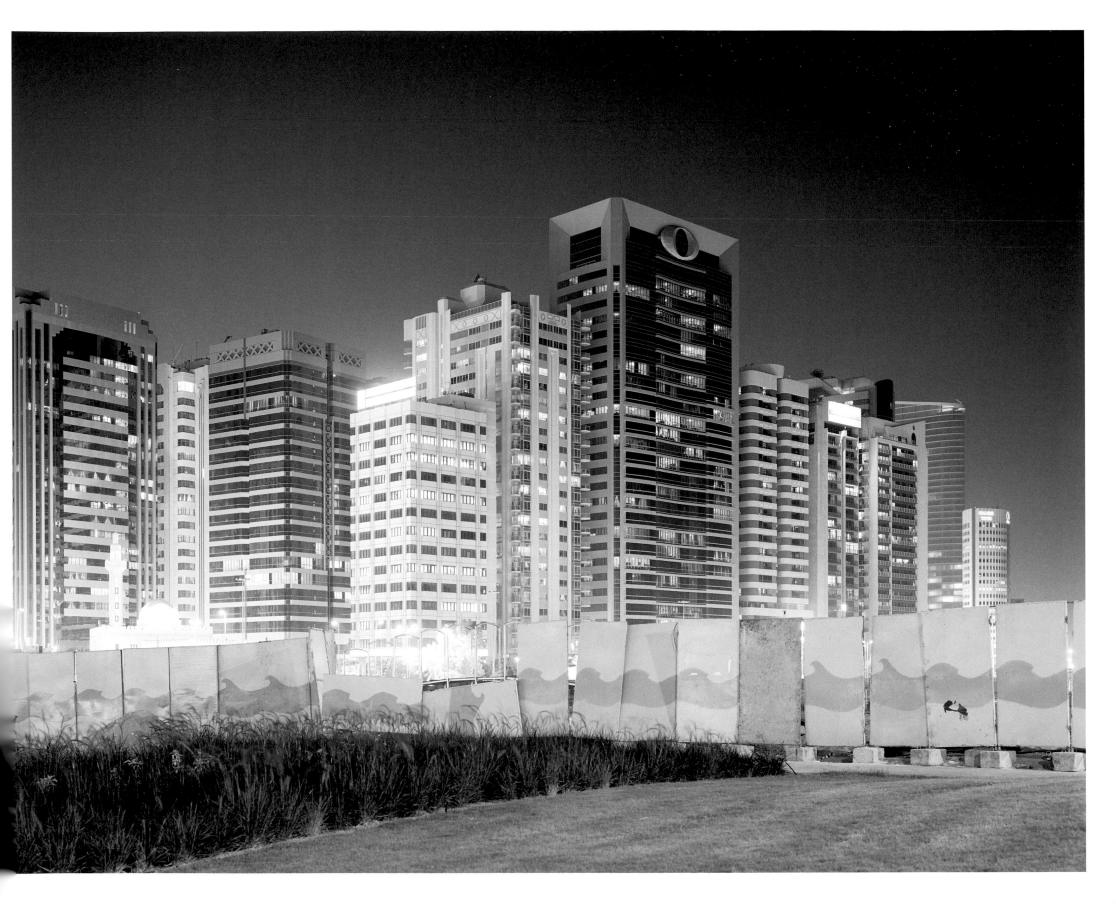

Transition 22

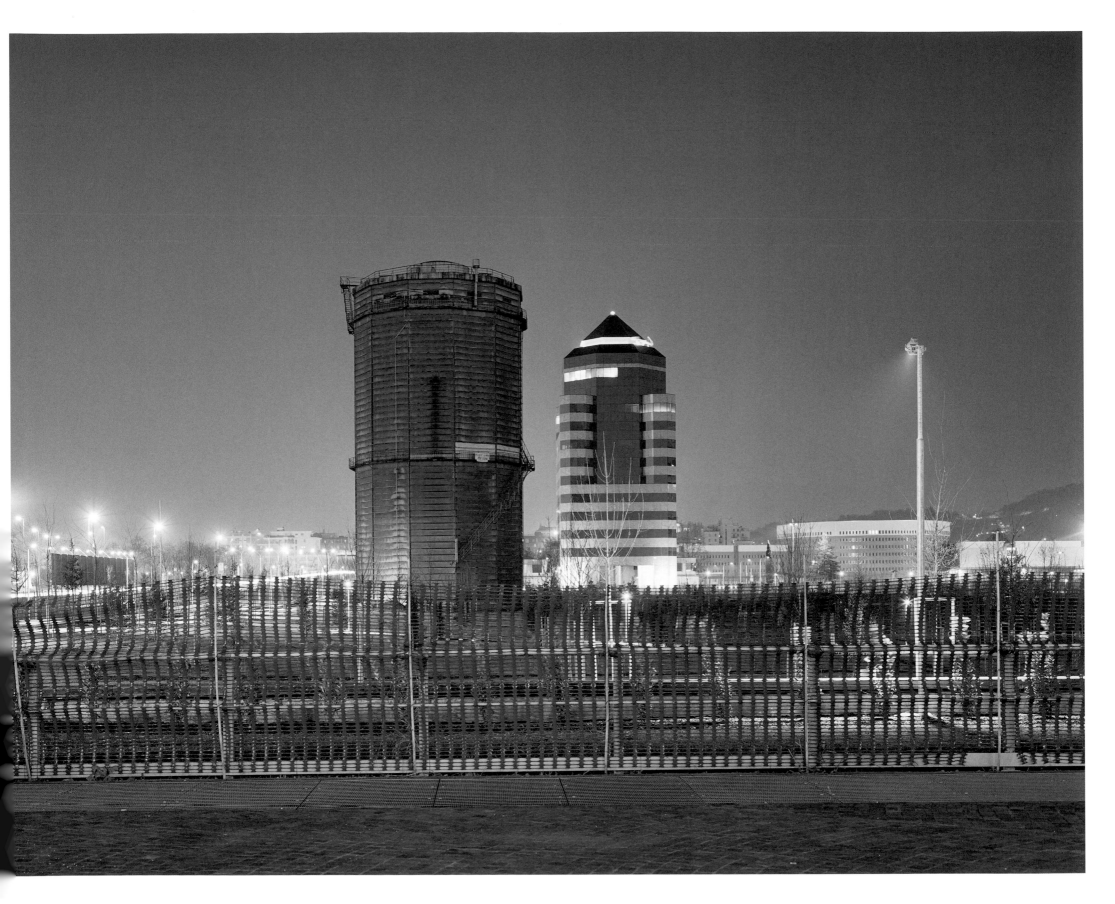

Transition 23

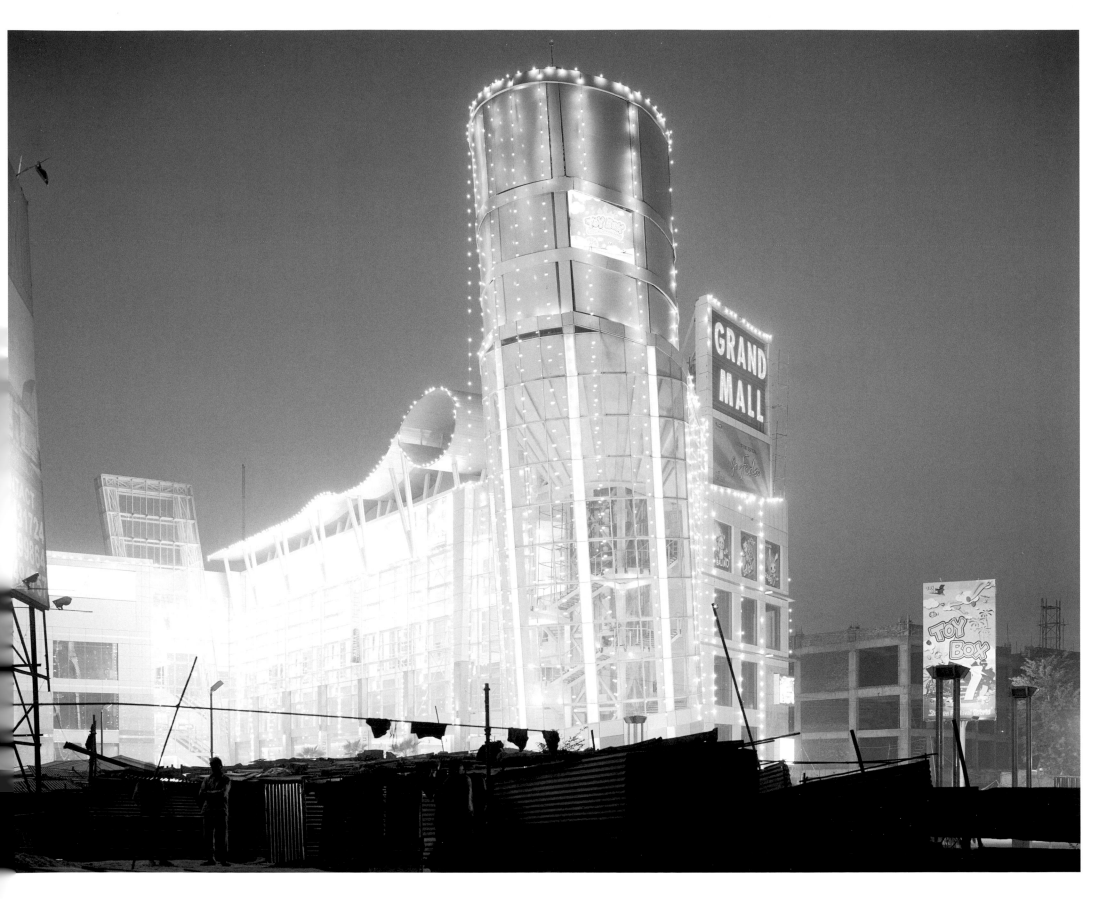

Transition 24

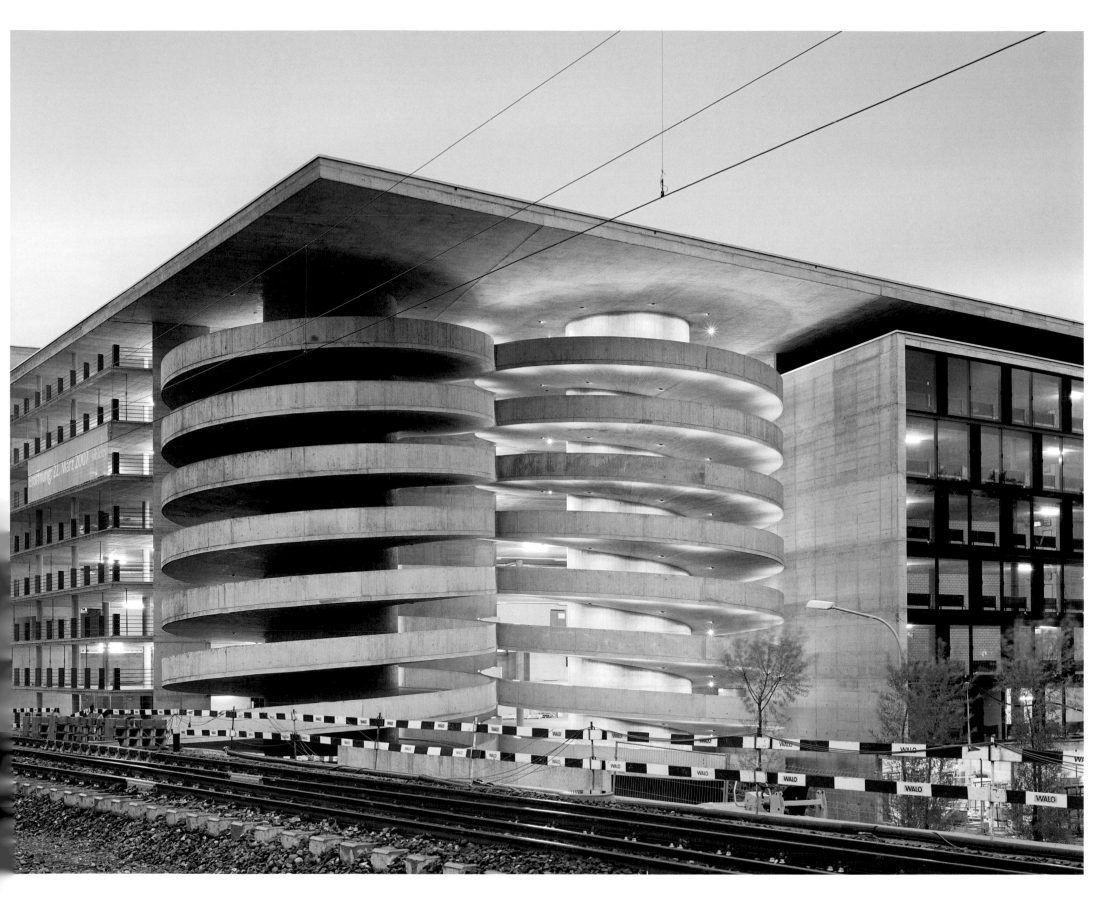

Transition 25

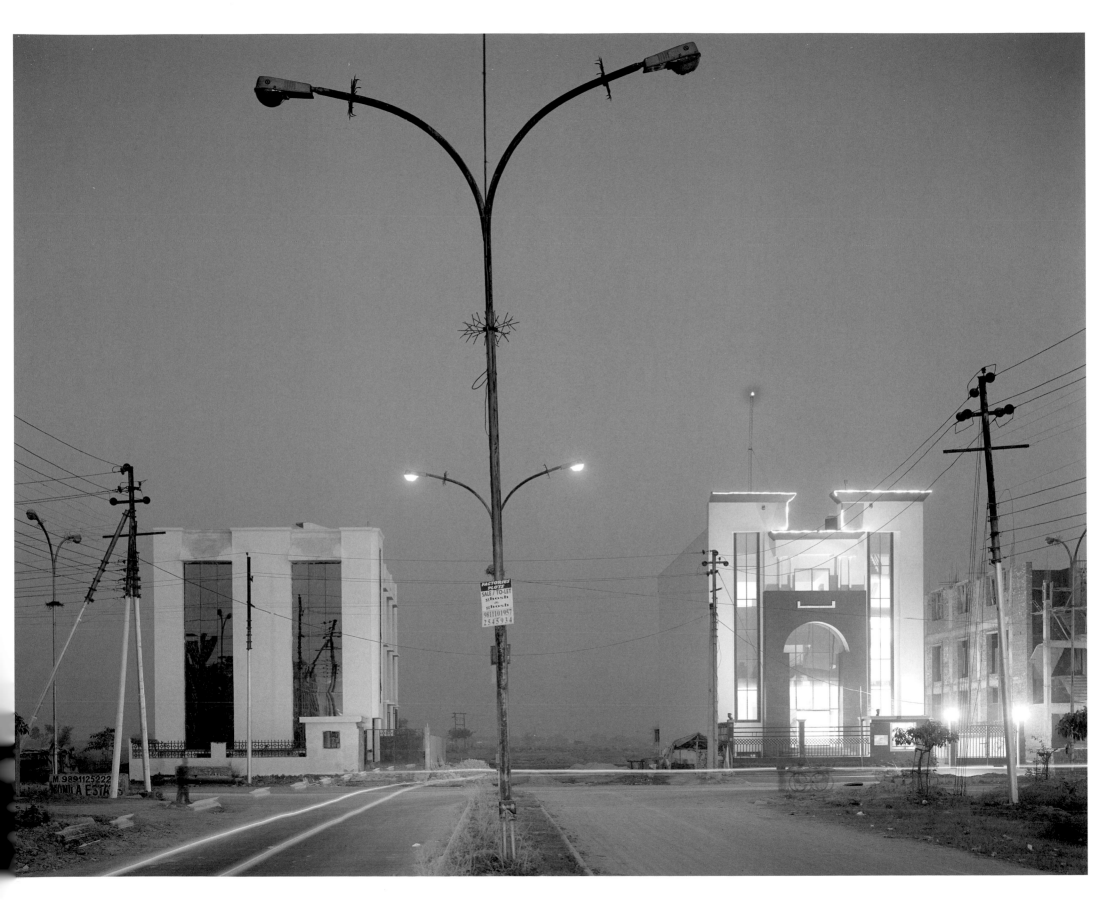

Transition 26

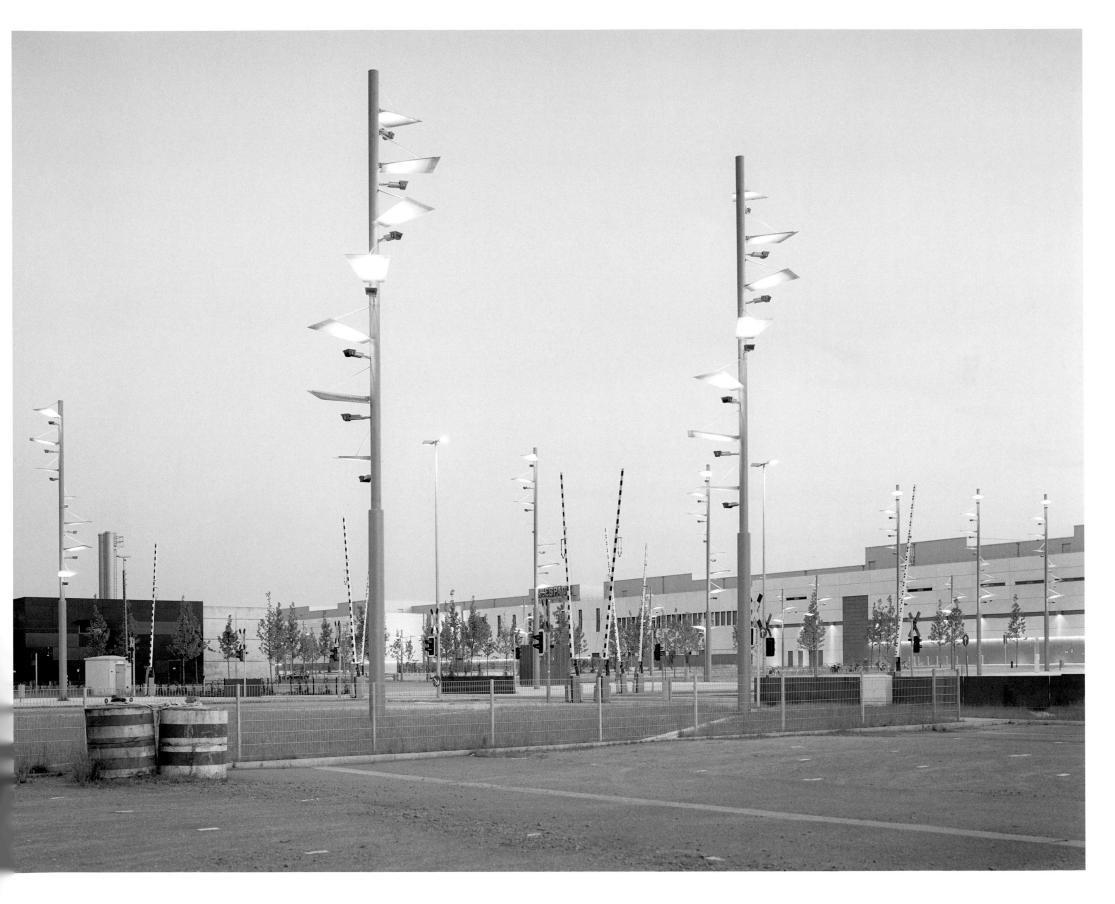

Transition 27

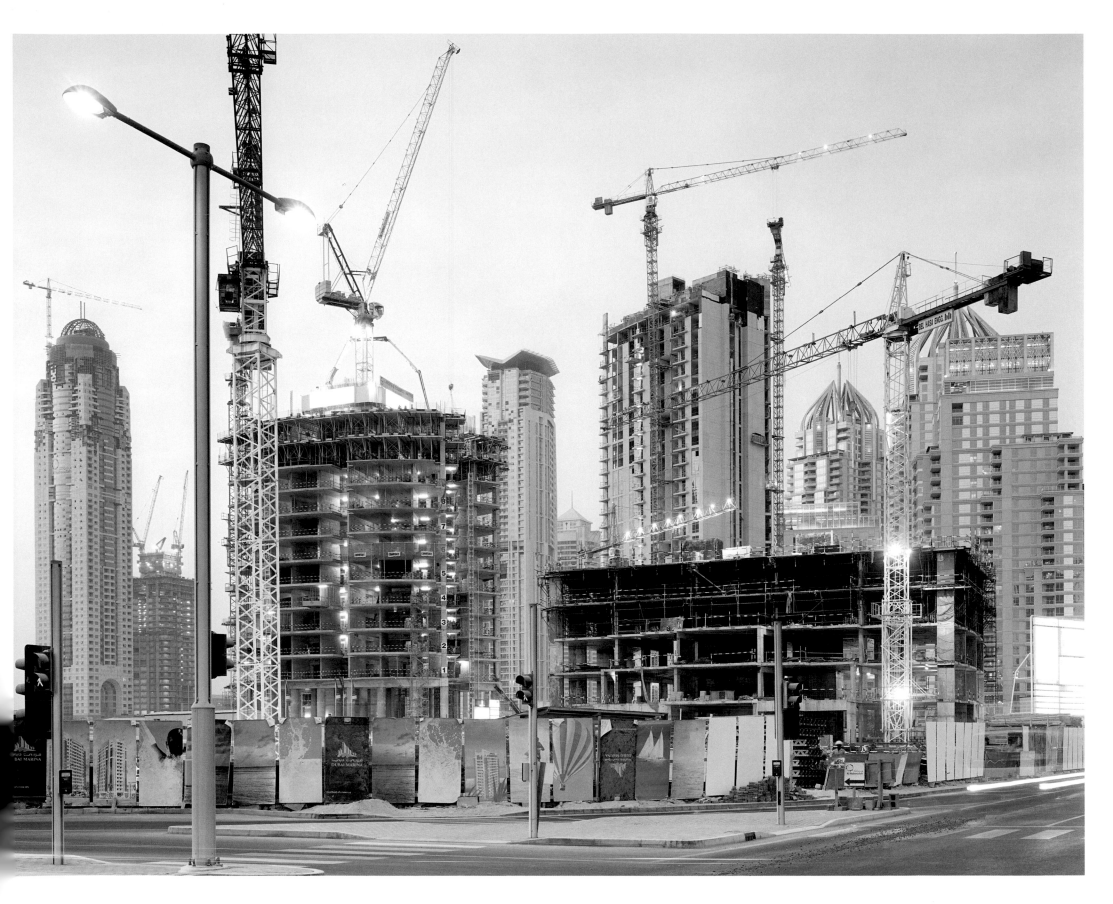

Transition 28

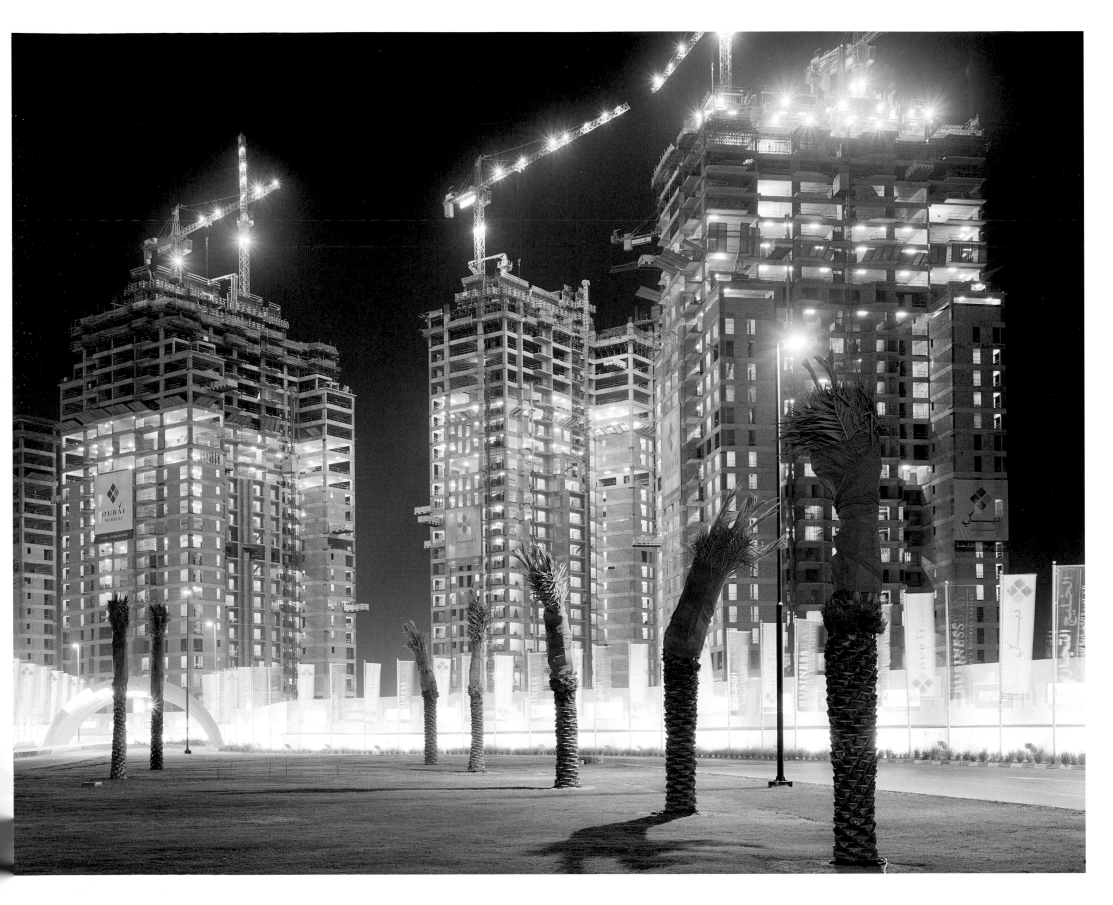

Transition 29

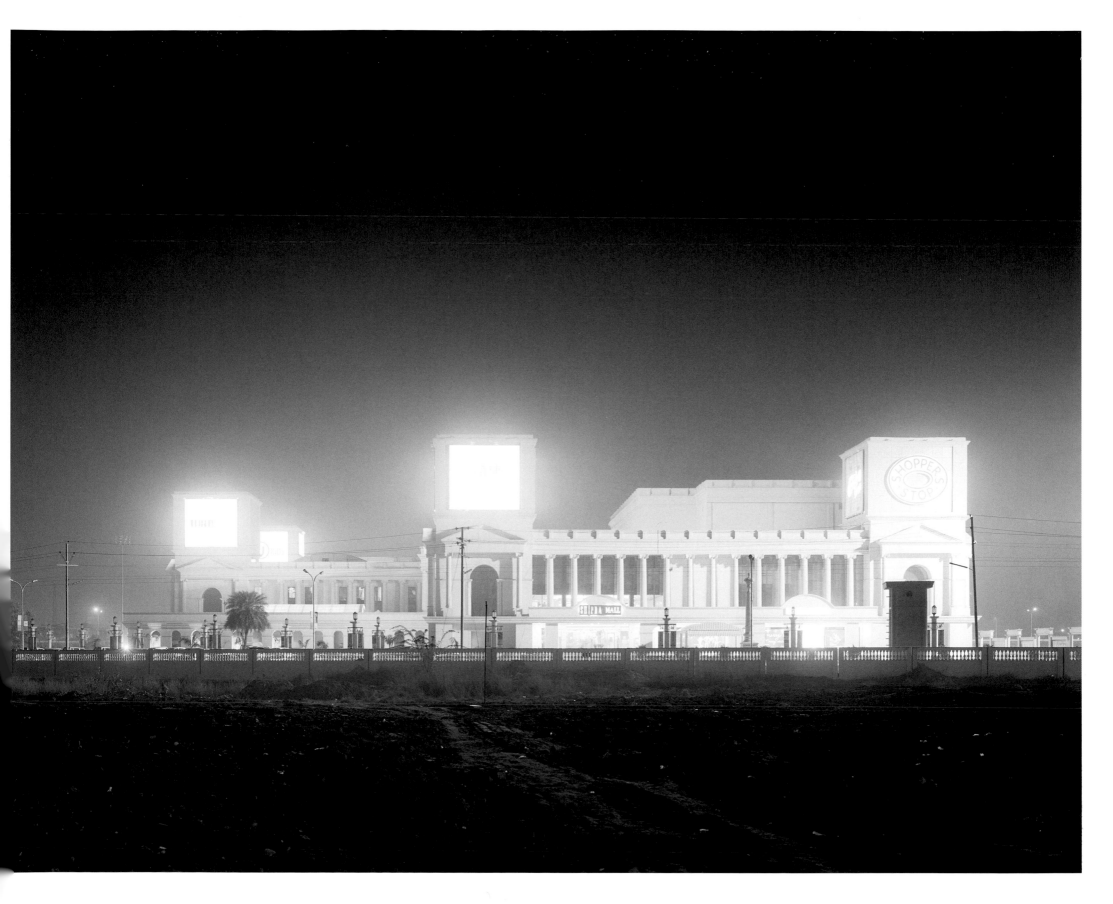

Transition 30

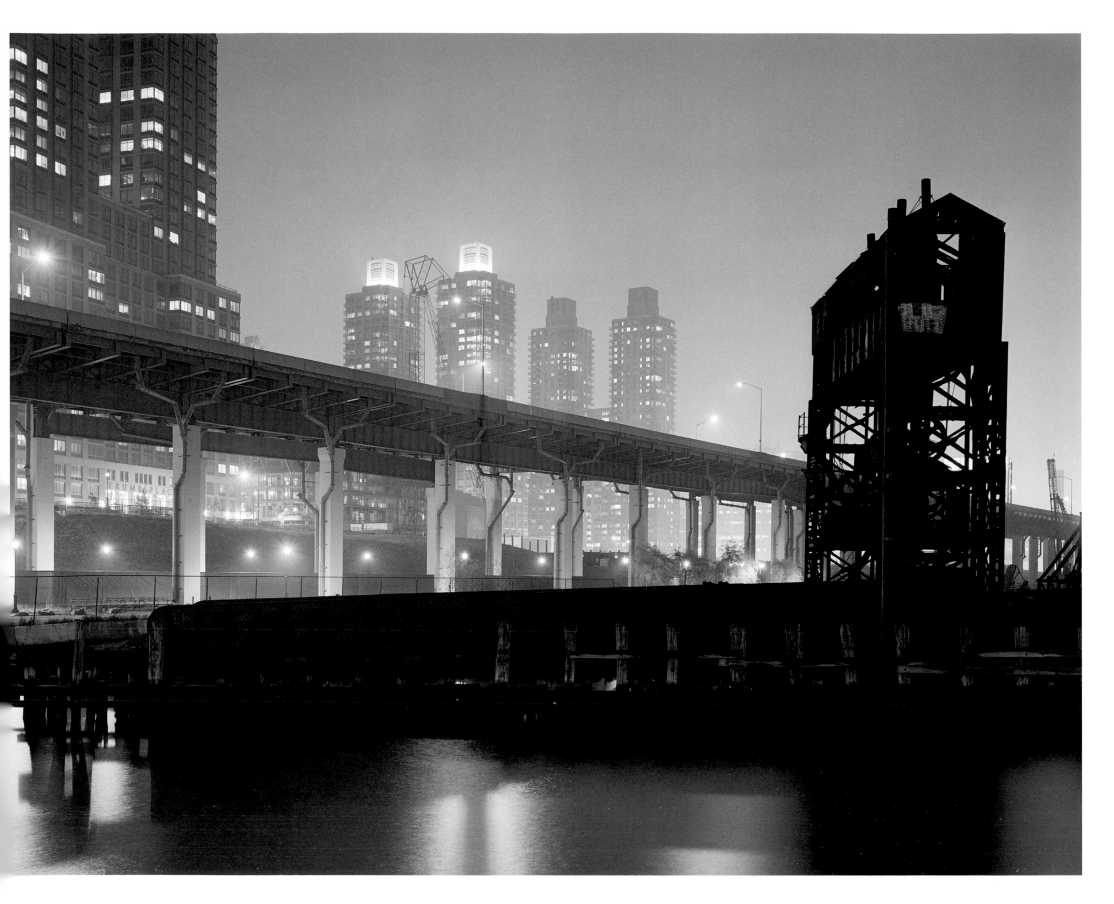

Transition 31

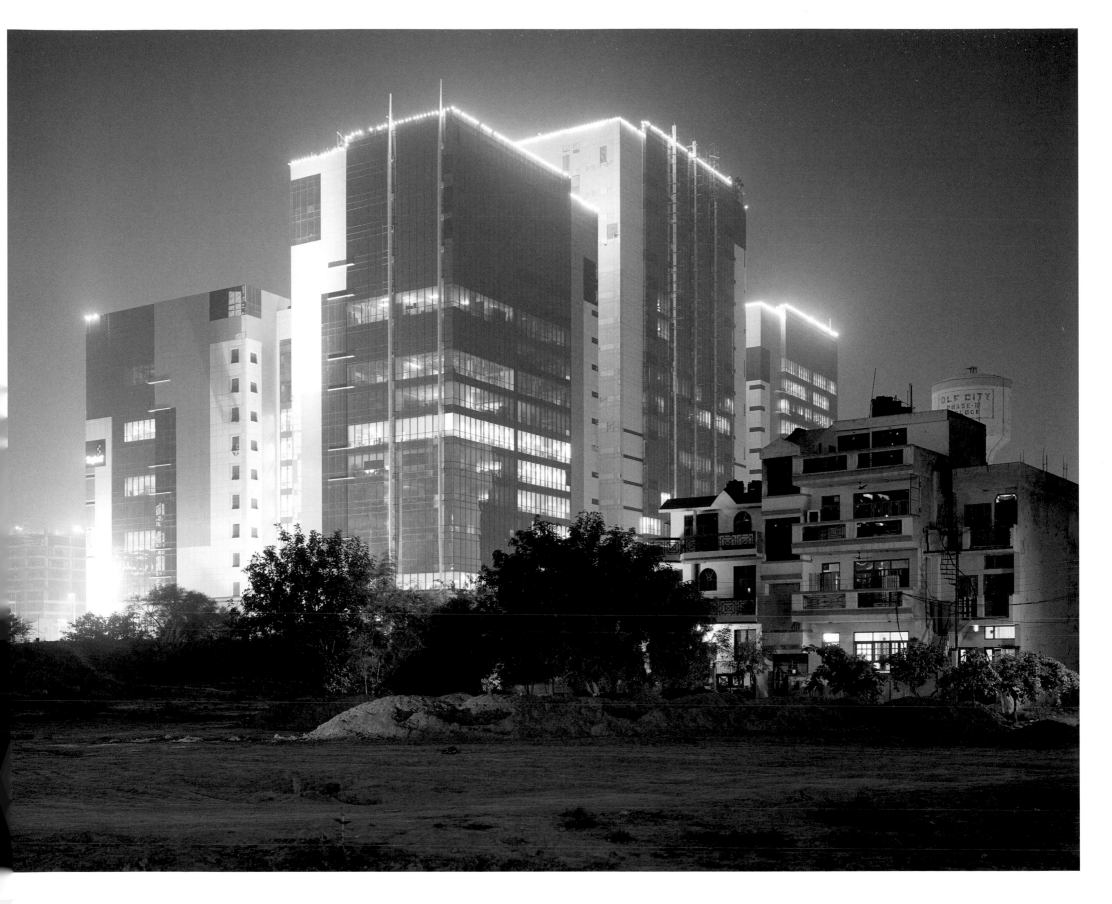

Transition 32

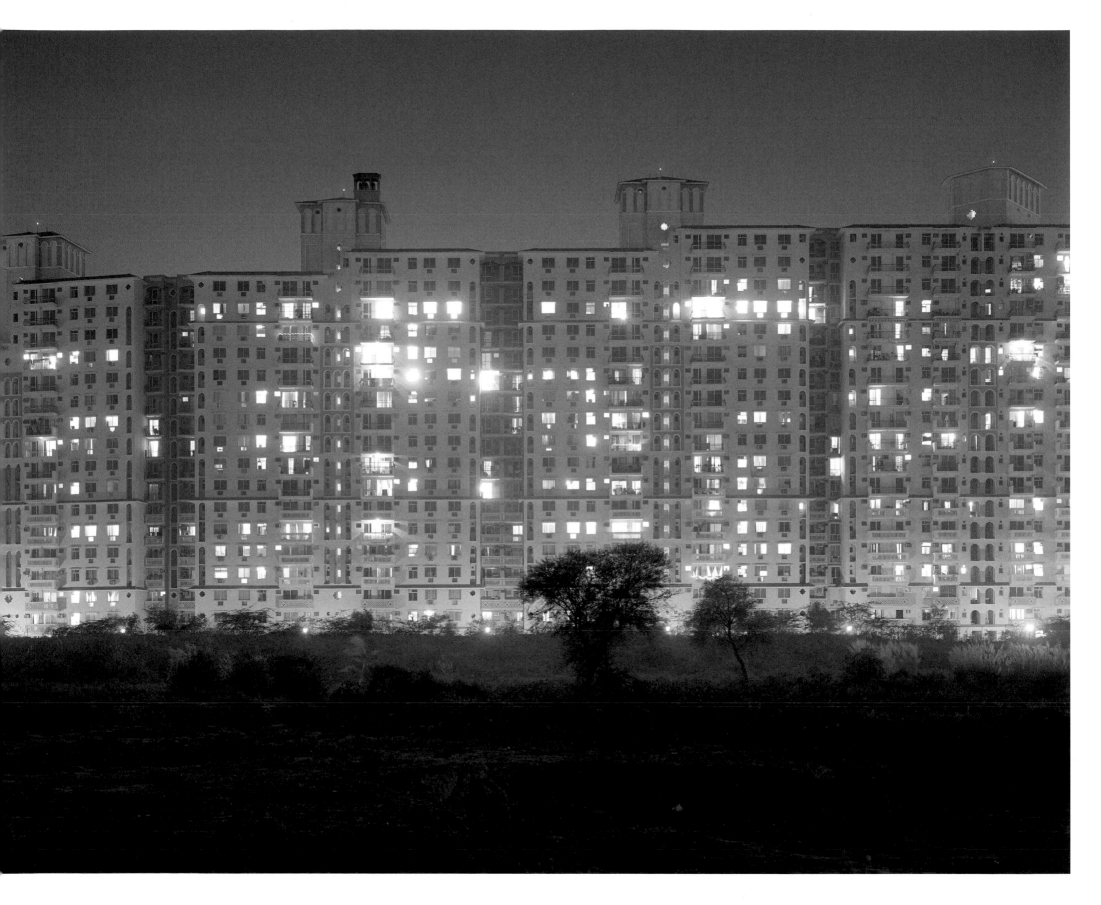

Transition 33

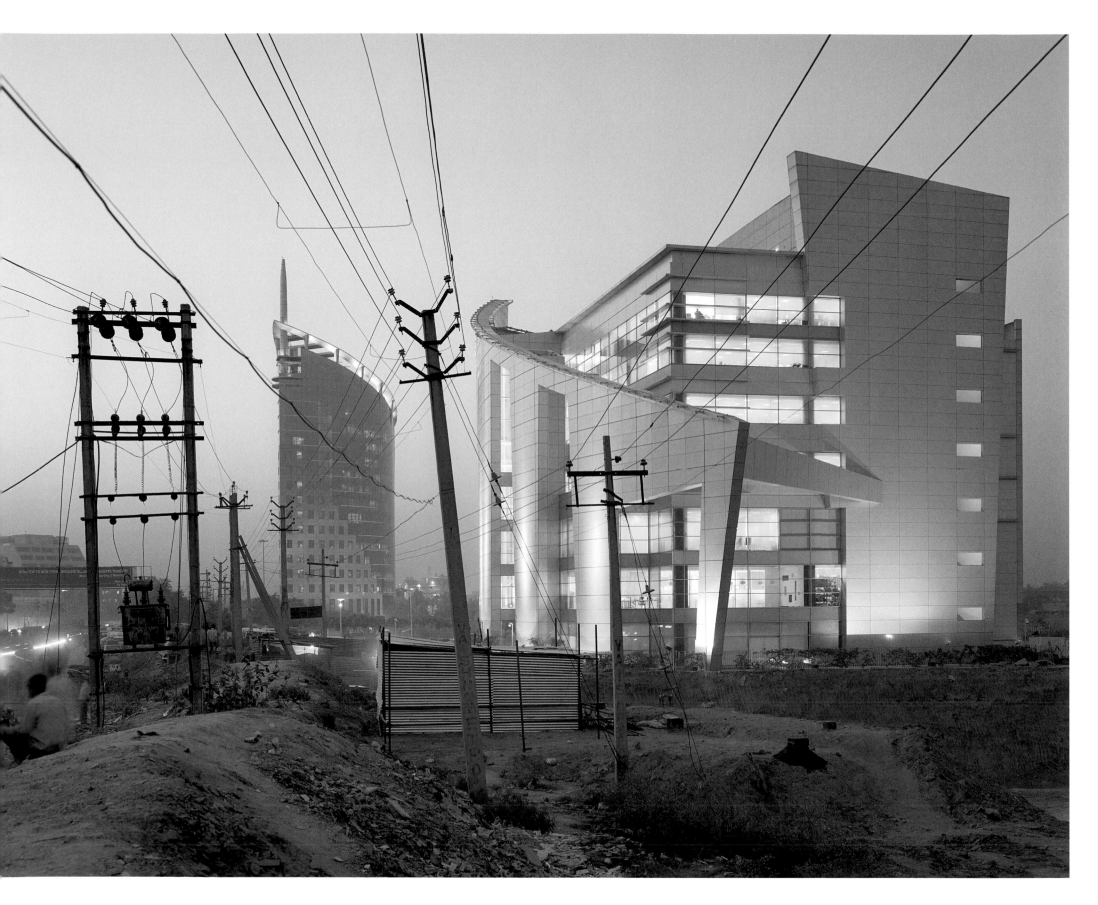

Transition 34

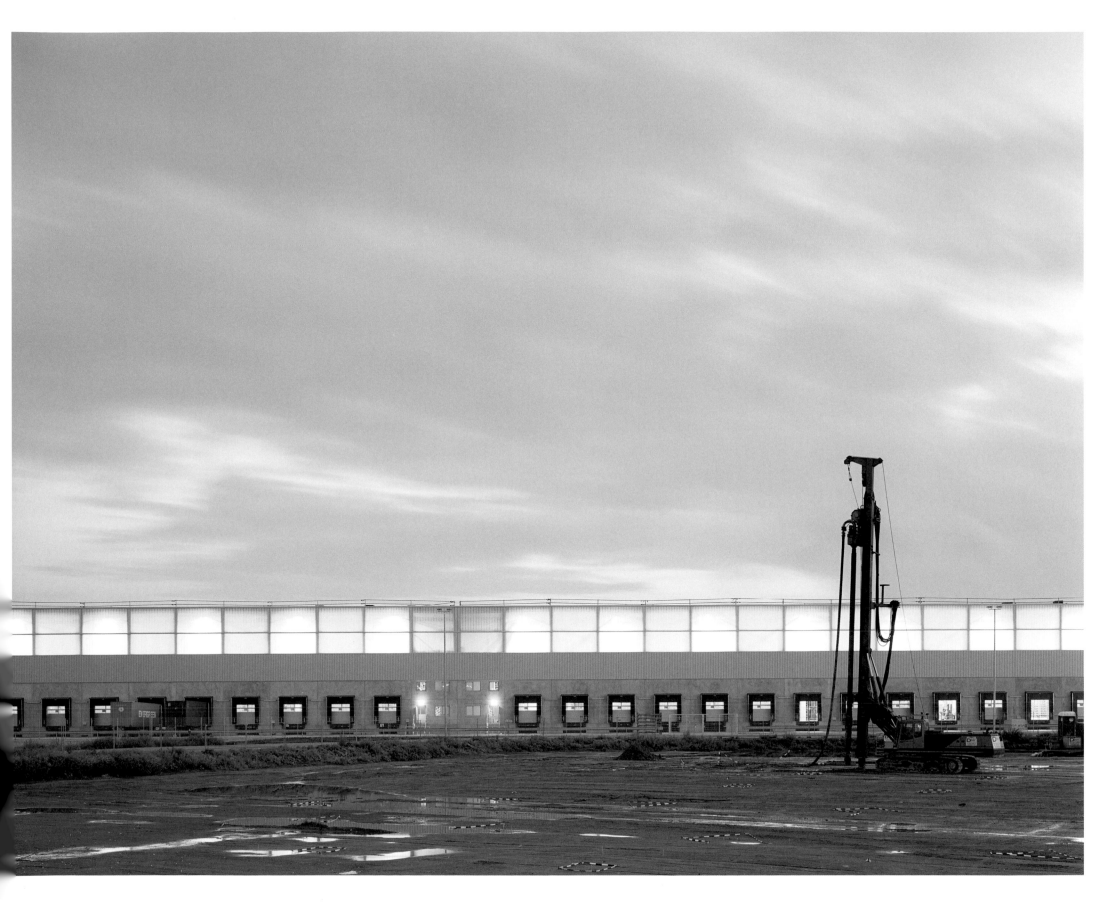

Transition 35

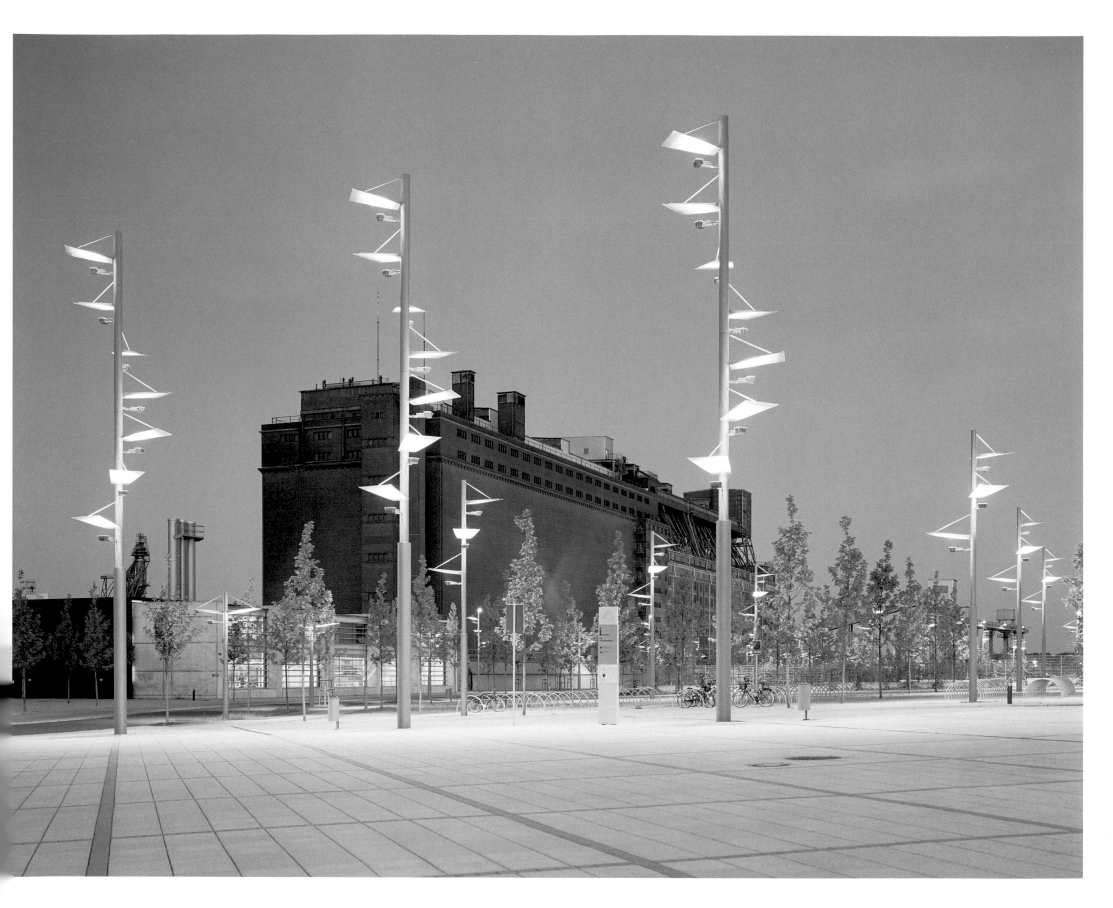

Transition 36

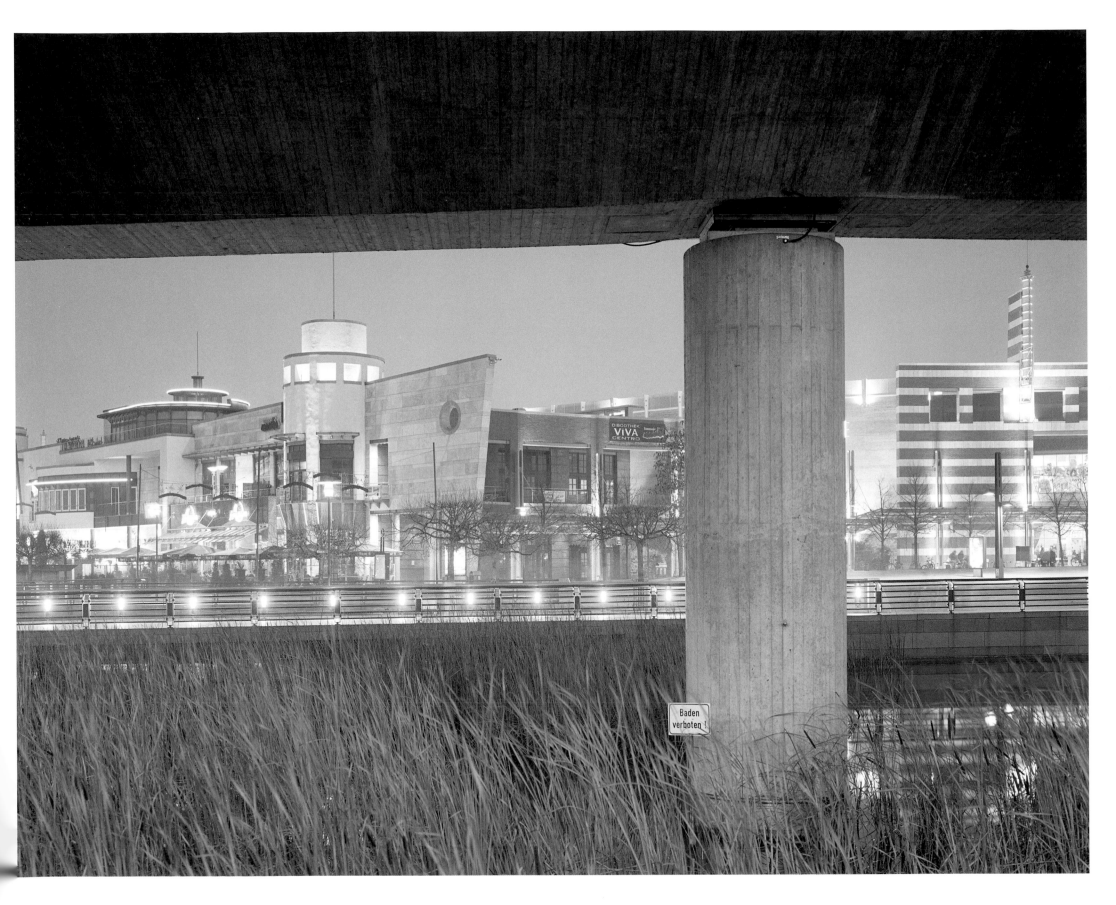

Transition 37

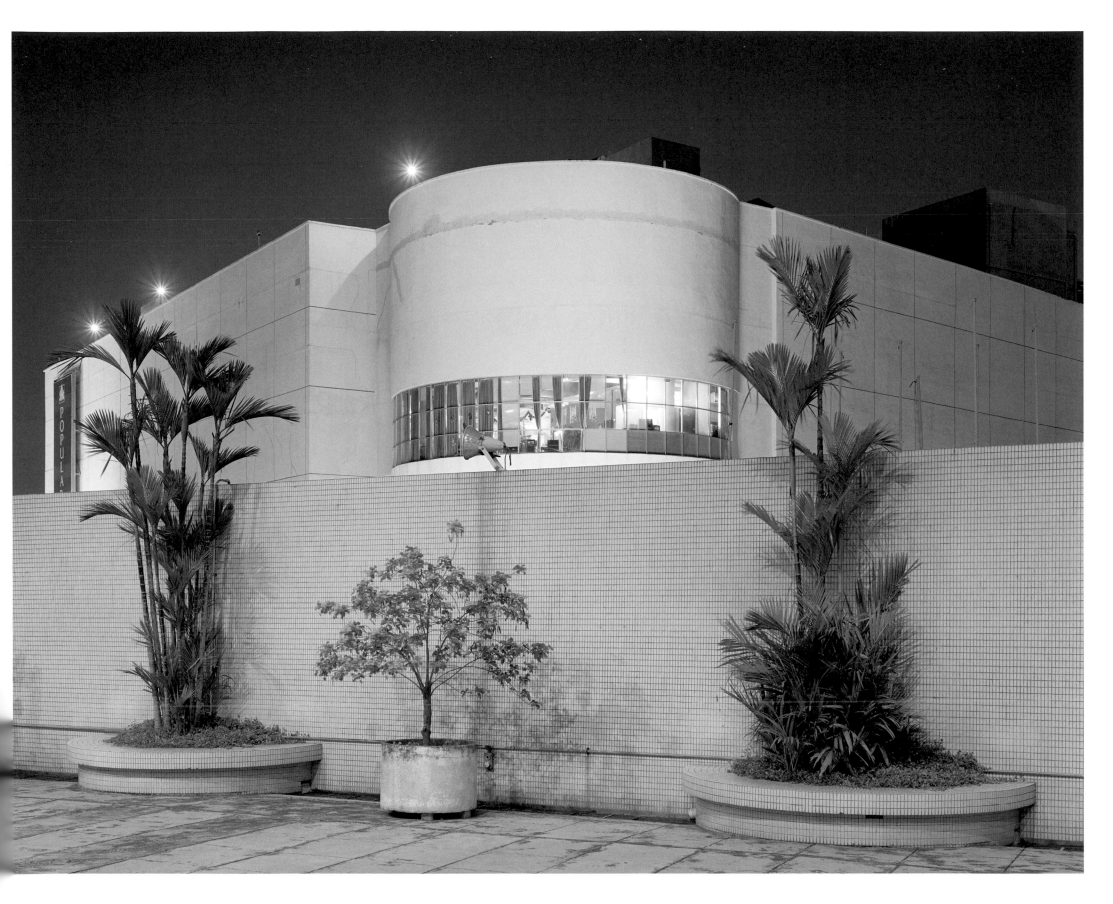

Transition 38

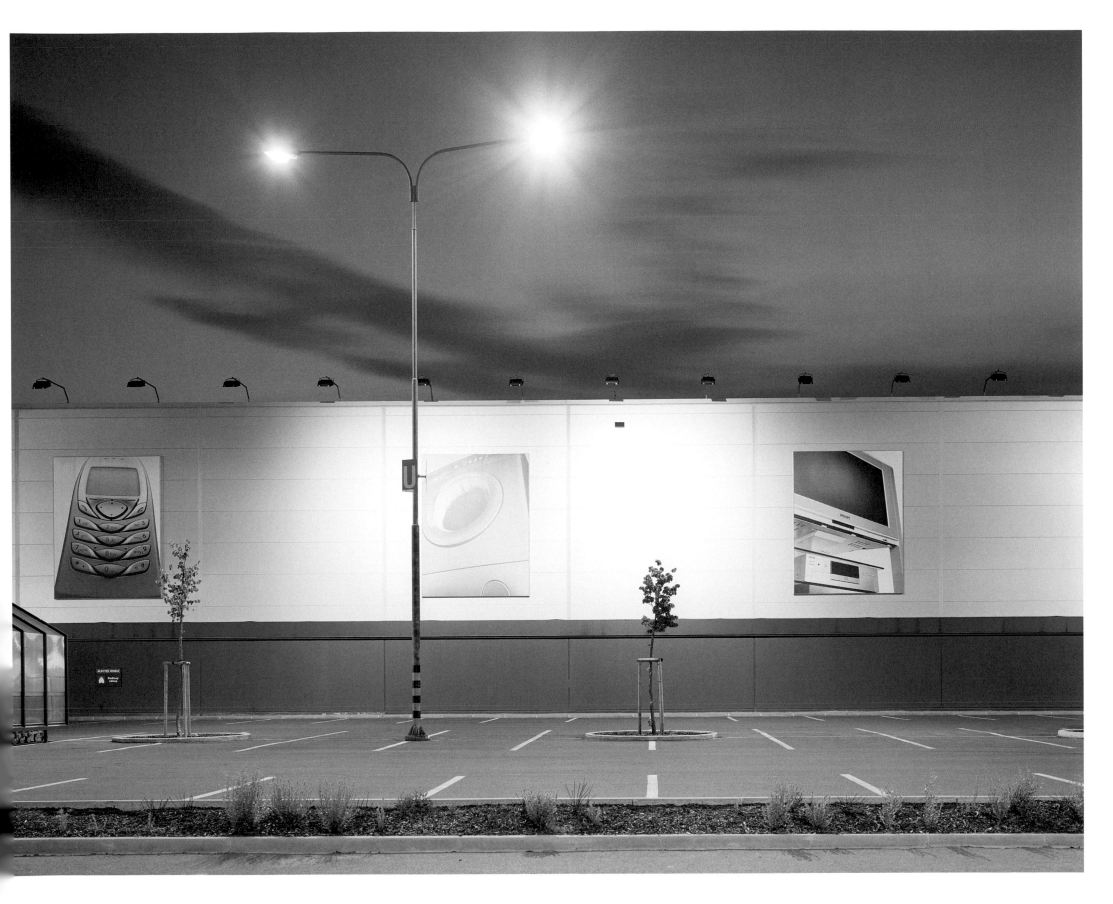

Transition 39

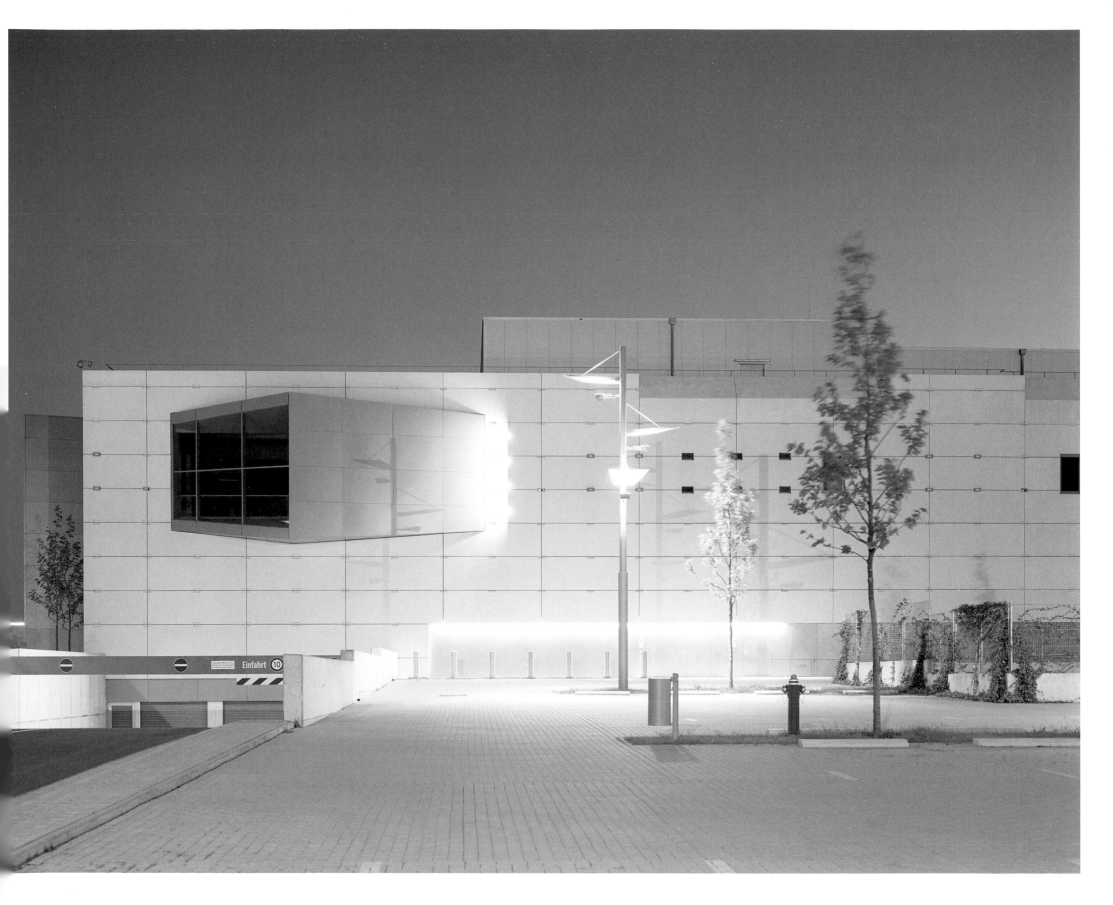

Transition 40

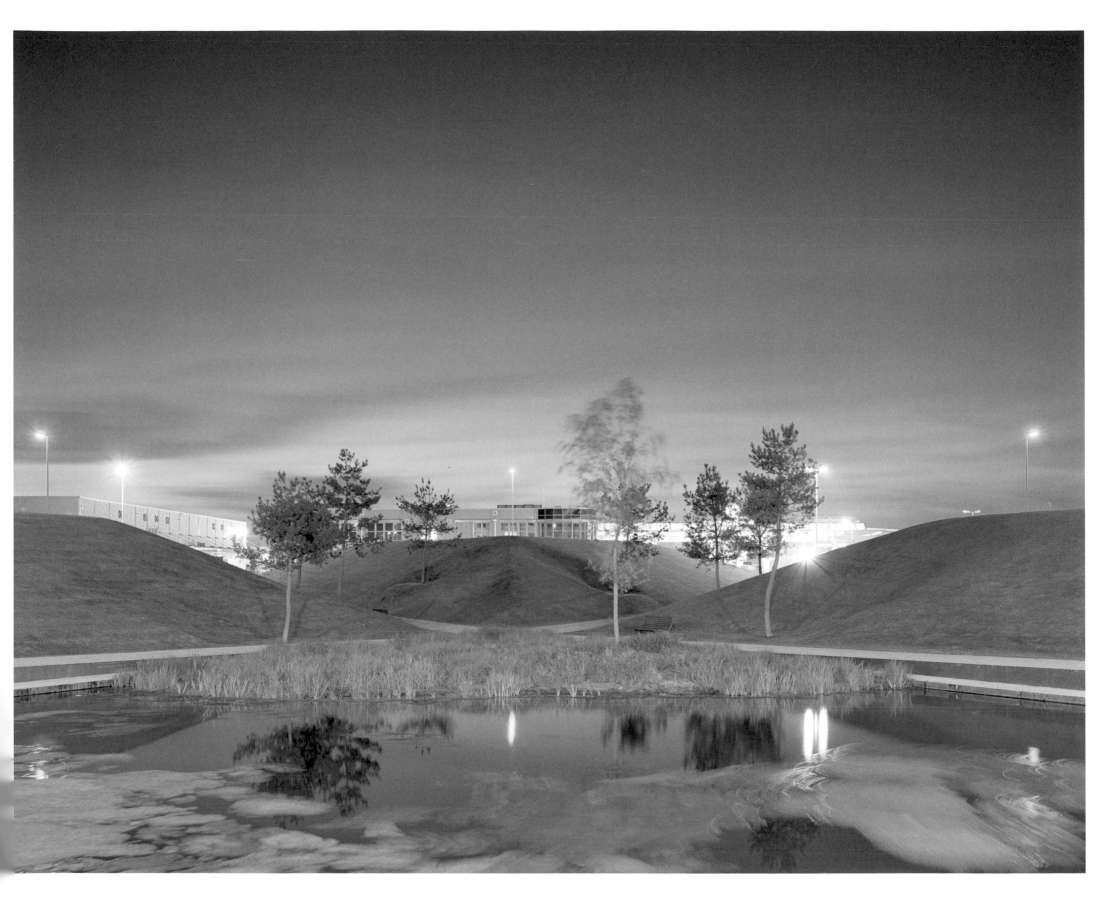

Transition 41

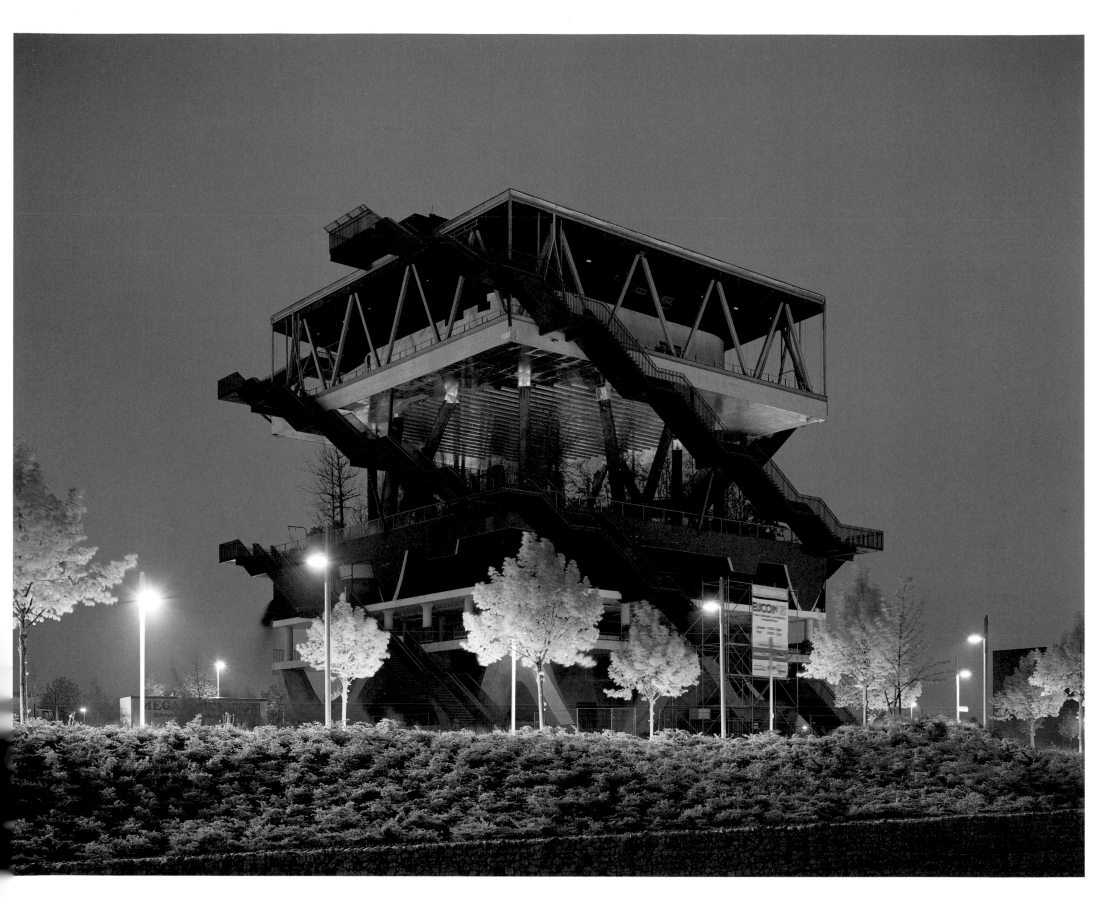

Transition 42

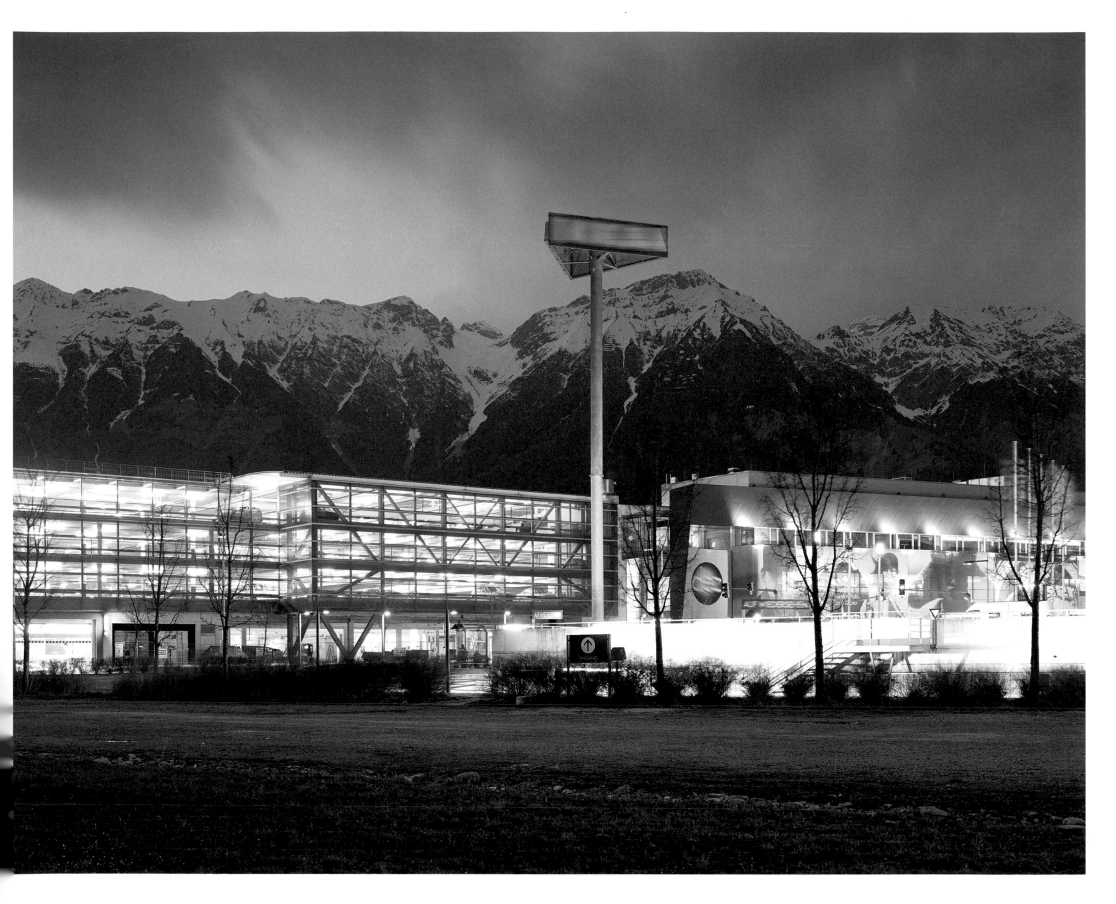

Transition 43

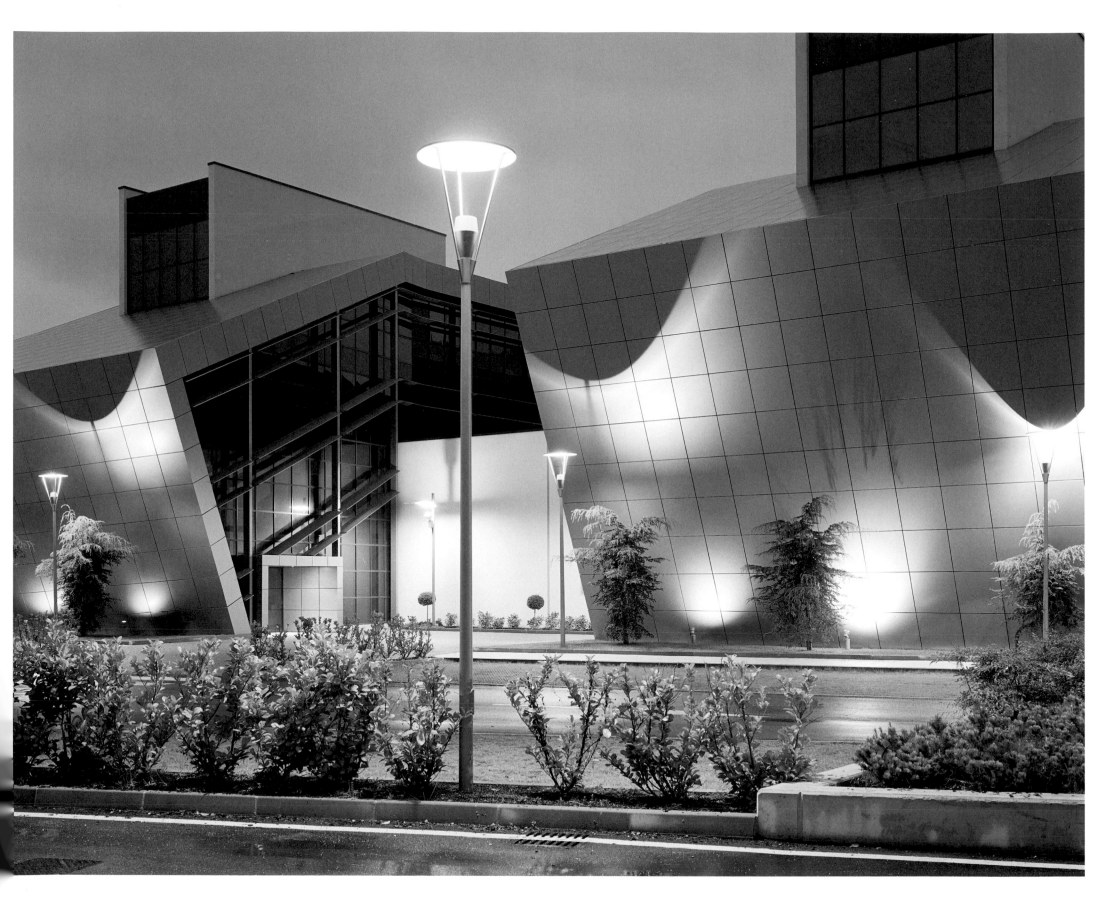

Transition 44

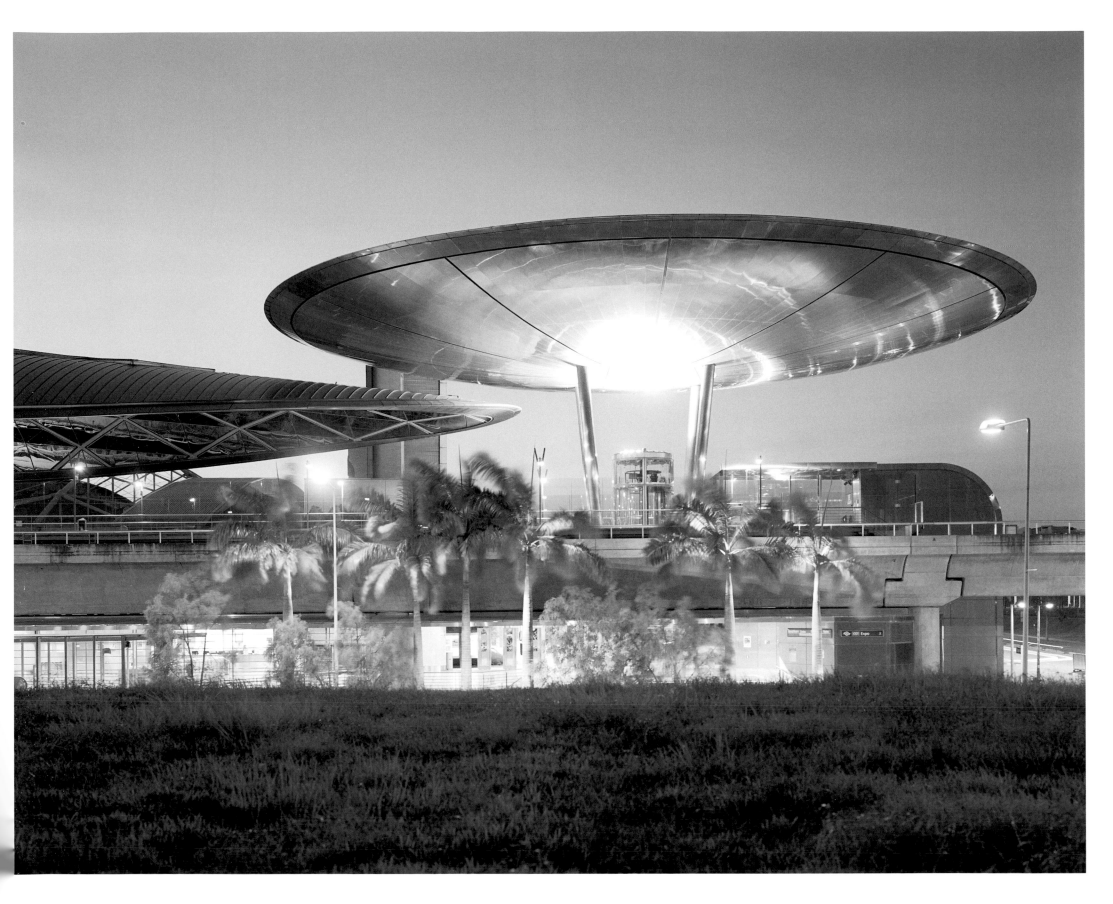

Transition 45

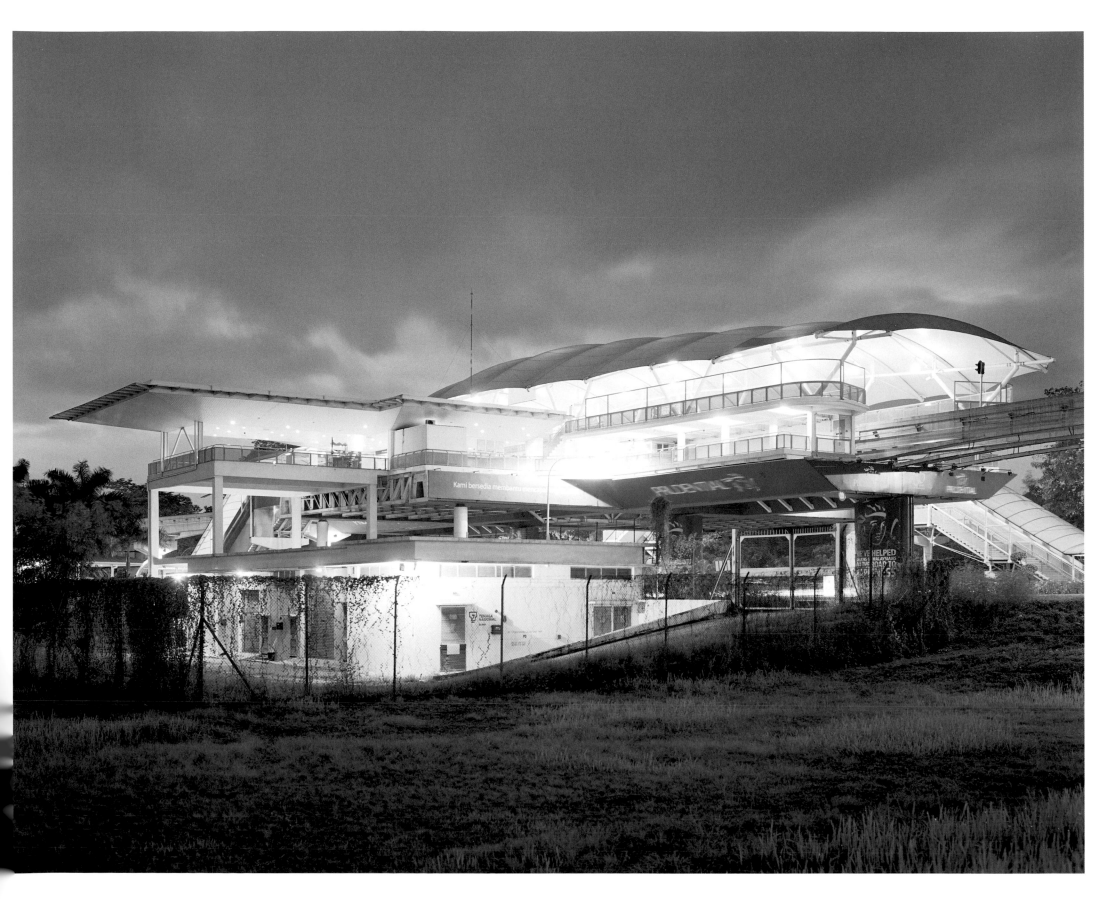

Transition 46

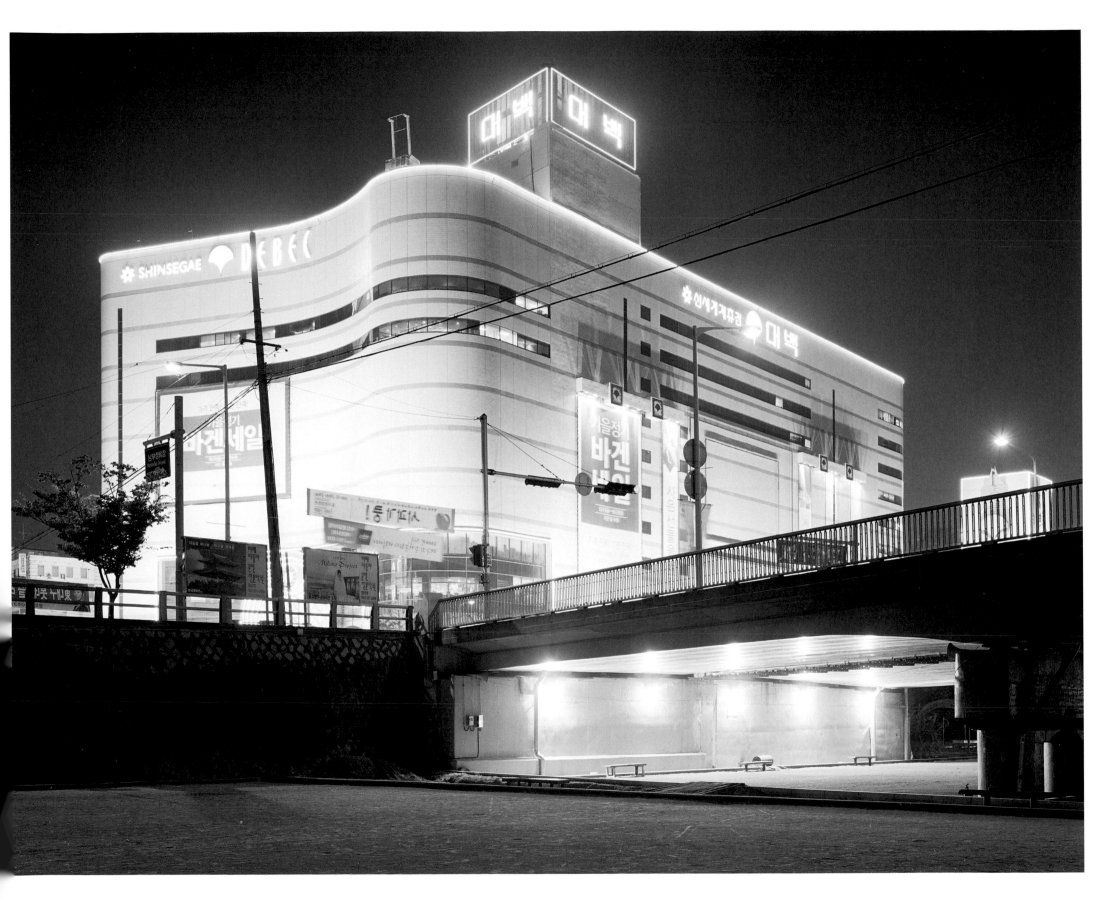

Transition 47

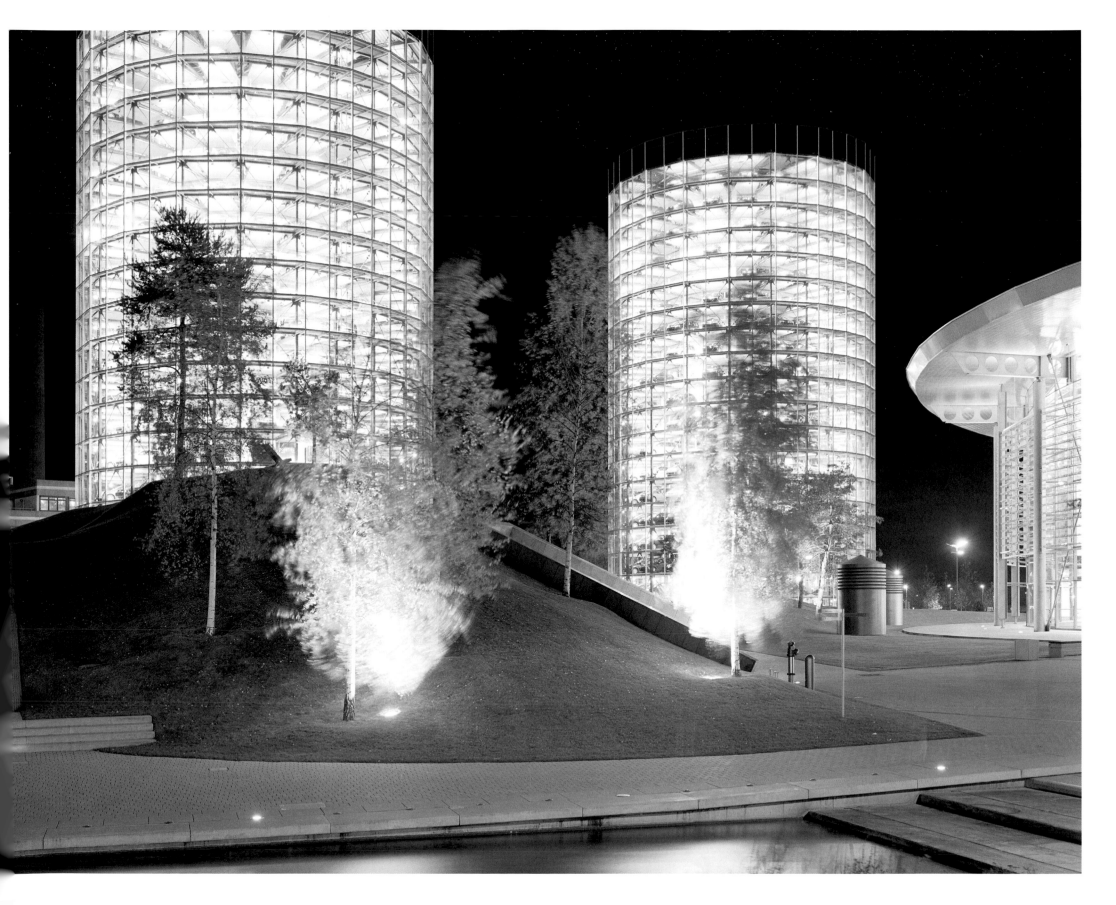

Transition 48

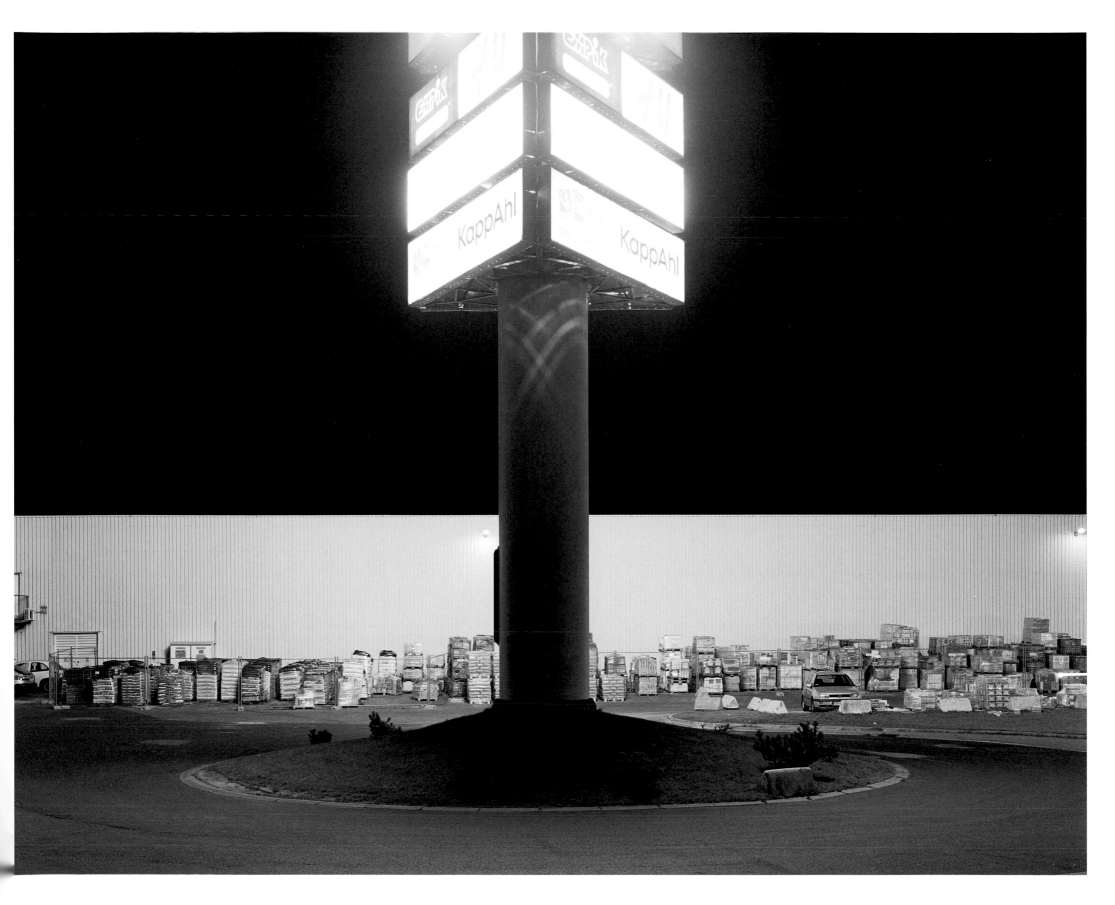

Transition 49

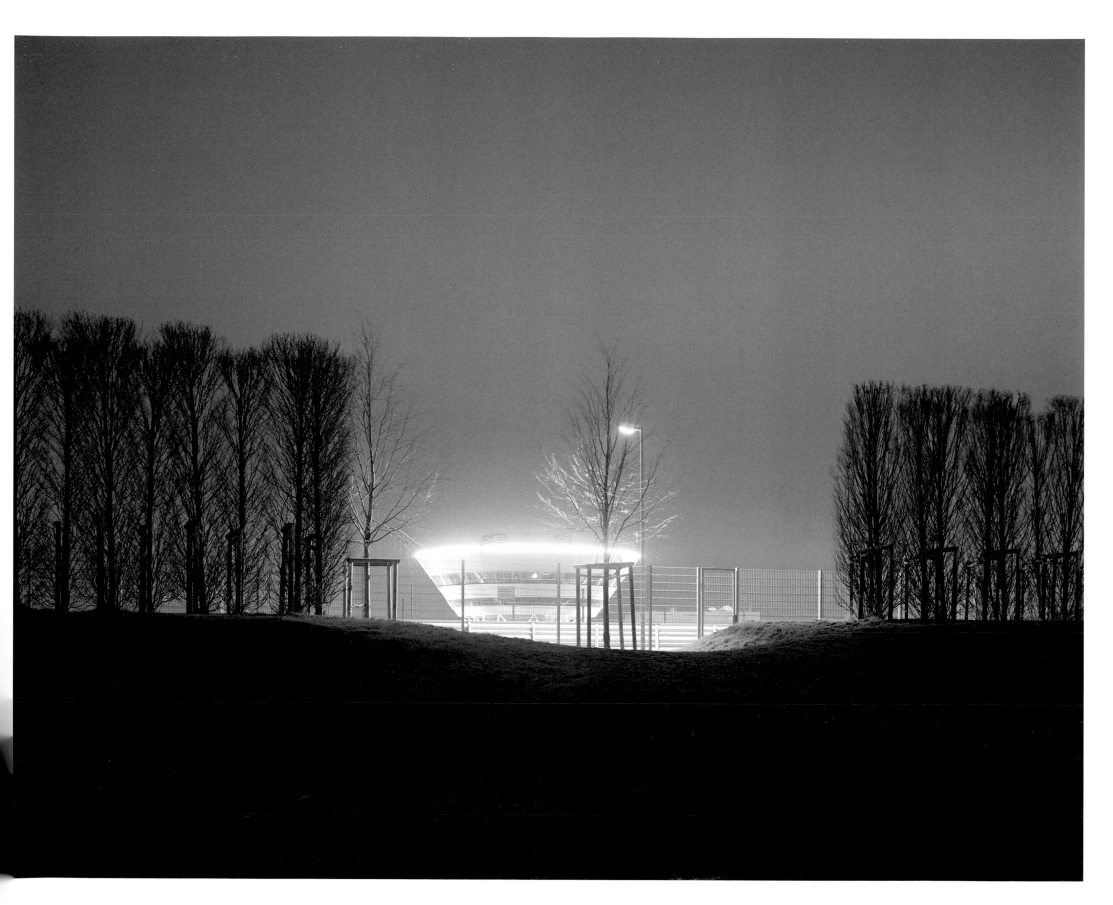

Transition 50

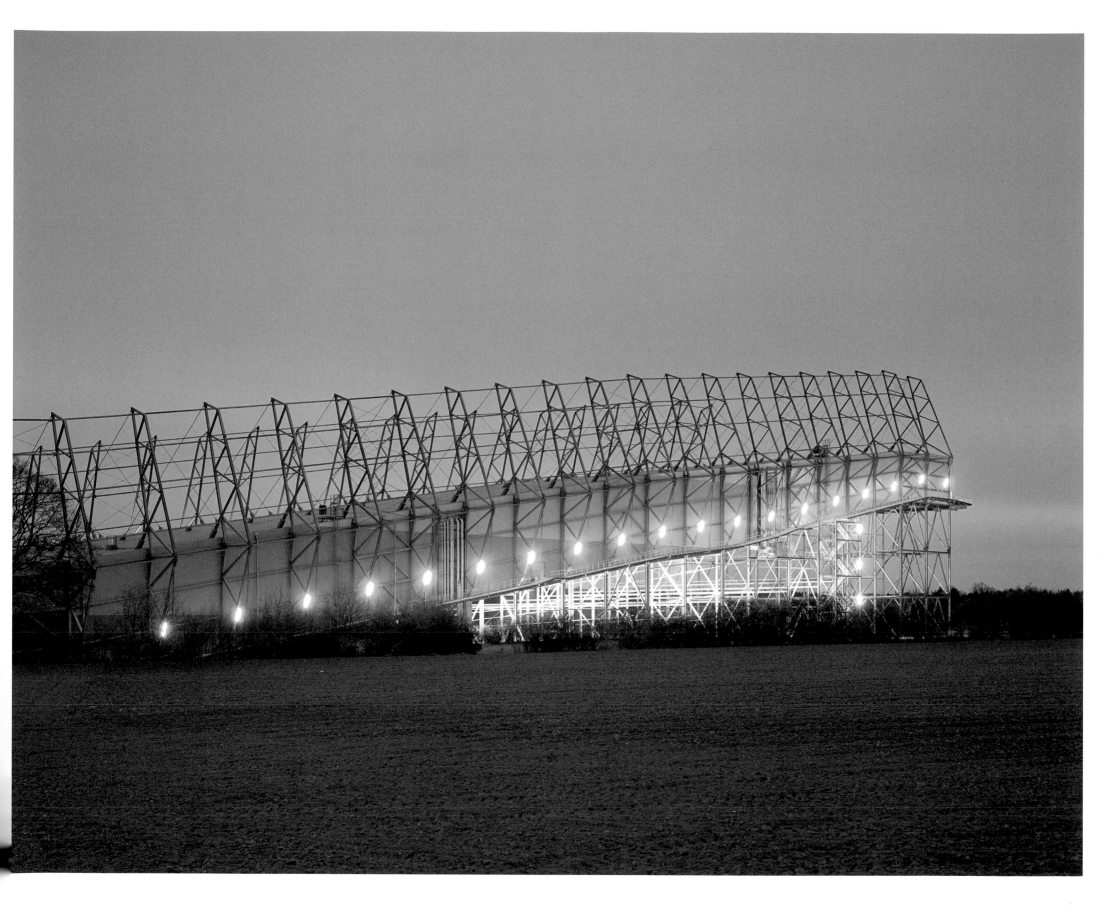

Transition 51

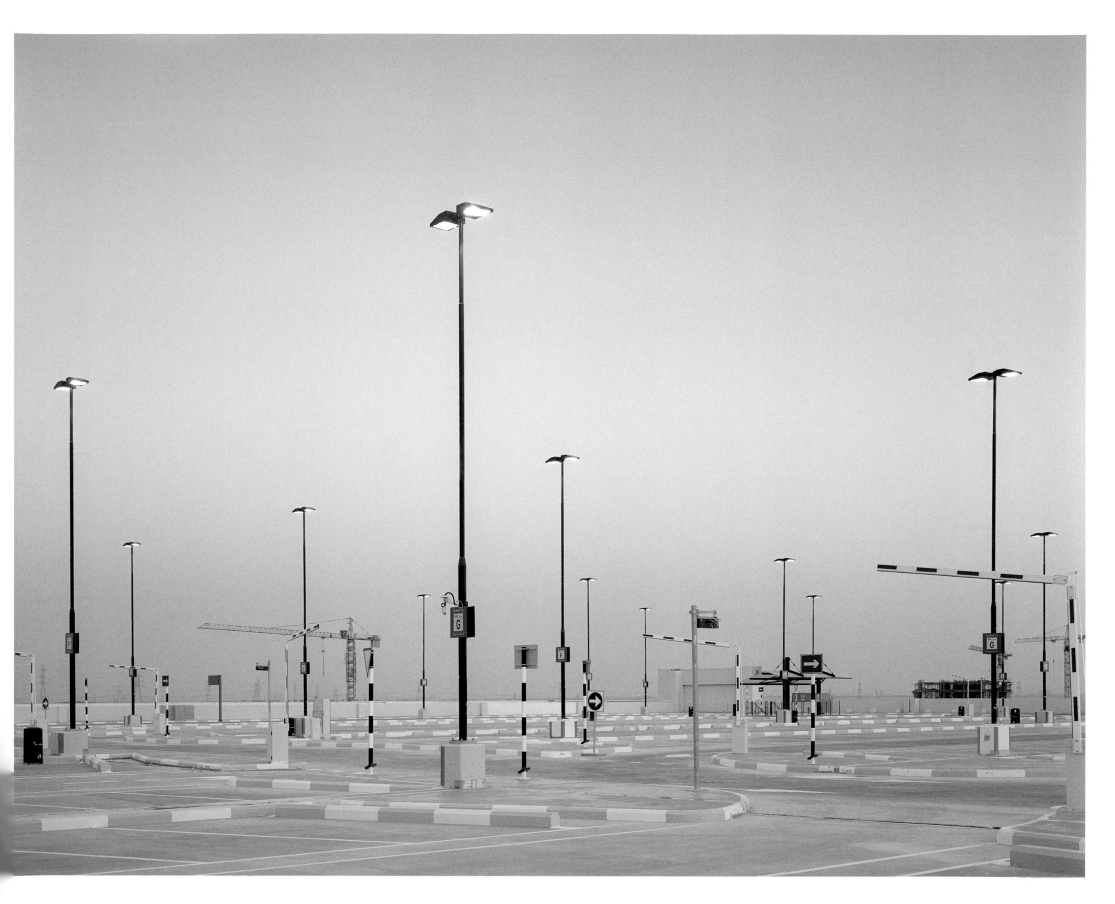

Transition 52

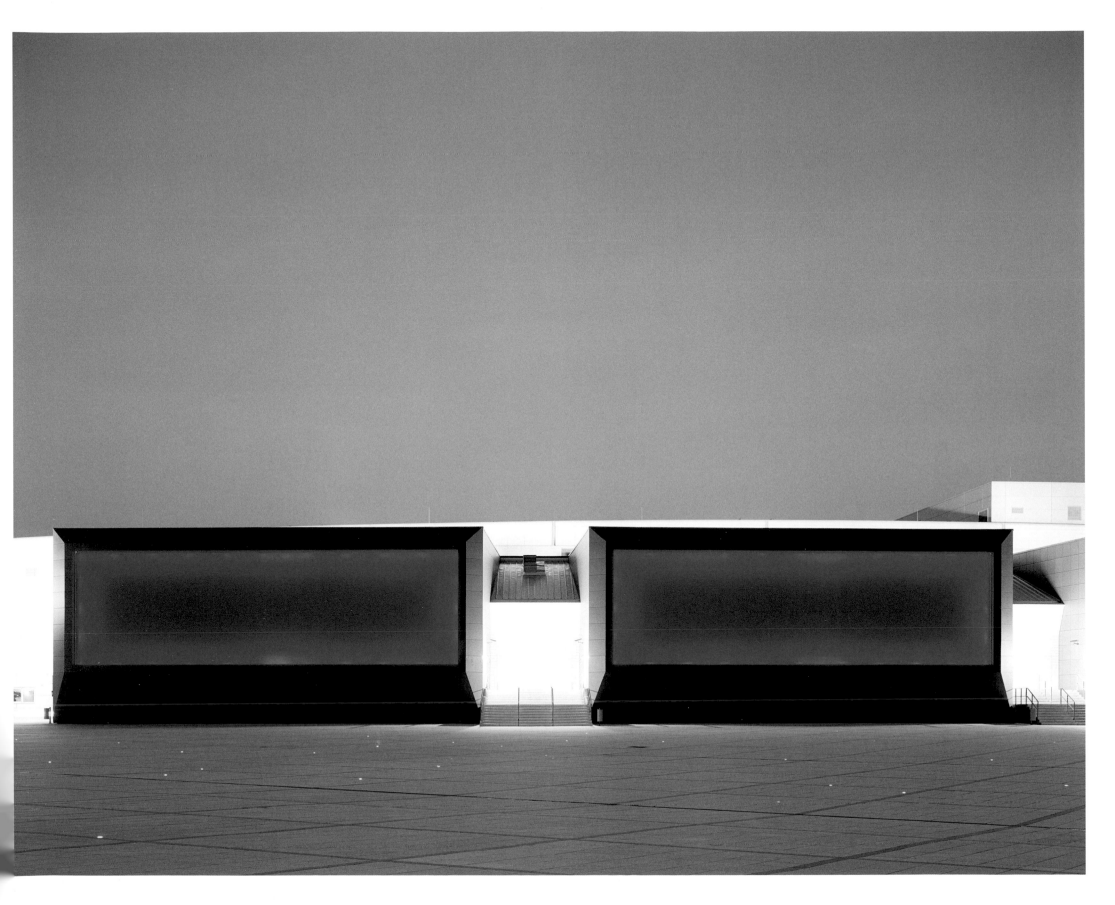

Acknowledgments

The photographs in this book were taken in Abu Dhabi, UAE; Auckland, New Zealand; Bispingen, Germany; Bitterfeld, Germany; Bremen, Germany; Brescia, Italy; Calcutta, India; Dubai, UAE; Gdańsk, Poland; George Town, Malaysia; Gurgaon, India; Hamburg, Germany; Hanover, Germany; Innsbruck, Austria; Jakarta, Indonesia; Kuala Lumpur, Malaysia; Leipzig, Germany; Moorfleet, Germany; New York, USA; Noida, India; Oberhausen, Germany; Ostrava, Czech Republic; Putrajaya, Malaysia; Rovereto, Italy; Singapore, Singapore; Taegu, South Korea; Wolfsburg, Germany; and Zurich, Switzerland, during a period of almost five years.

As I went along, the places I photographed became completely unimportant in terms of the meaning and abstract connotations of the photographs. Due to the advent of GPS systems built into cameras, I decided, for the first time, to take the liberty of saying just that the pictures in this book were photographed on four continents, in fourteen countries, and in twenty-eight cities around the world, without specifying the location of each individual photograph.

Countless people during my travels have helped me and will forgive me if I can't mention everyone in person. Michael Glasmeier provided the sharp and intelligent essay in this book for which I feel honored. I am especially grateful to Markus Hartmann of Hatje Cantz for his ongoing belief in my work. The wonderful typographer Indra Kupferschmid designed this publication, the second one for me, for which I kiss her again. My teaching position at the University of the Arts in Bremen and the ongoing discussion with my students has forced me to think even harder about my own work. It was a privilege working with all of you! Peter Rautmann, Peter Schäfer, and Markus Wortmann have supported my urge for frequent departures from the university into the rest of the world, without which quite a few images would not exist.

A few more to come: Ruth Eichhorn for helping to fund the work in Dubai; Anna Gripp and Denis Brudna for their friendship, willingness to debate, and advice; Heiko Sievers from the Goethe-Institut for telling me about Gurgaon and bringing me and my work to India. And above all, a great big thank-you to my friends who, as always, offered comfort and help when I was in need of it.

Peter Bialobrzeski
Hamburg, May 2007

Danksagung

Die Fotografien in diesem Buch wurden während einer Zeitspanne von fast fünf Jahren in Abu Dhabi, Vereinigte Arabische Emirate; Auckland, Neuseeland; Bispingen, Deutschland; Bitterfeld, Deutschland; Bremen, Deutschland; Brescia, Italien; Dubai, Vereinigte Arabische Emirate; Gdańsk, Polen; George Town, Malaysia; Gurgaon, Indien; Hamburg, Deutschland; Hannover, Deutschland; Innsbruck, Österreich; Jakarta, Indonesien; Kalkutta, Indien; Kuala Lumpur, Malaysia; Leipzig, Deutschland; Moorfleet, Deutschland; New York, USA; Noida, Indien; Oberhausen, Deutschland; Ostrava, Tschechien; Putrajaya, Malaysia; Rovereto, Italien; Singapur, Singapur; Taegu, Südkorea; Wolfsburg, Deutschland; und Zürich, Schweiz, aufgenommen.

Im Laufe der Zeit wurden die Orte, die ich fotografierte, unwichtig im Hinblick auf die Bedeutung und abstrakte Konnotation der entstandenen Fotografien. In einer Zeit, in der verstärkt GPS-Empfänger in Kameras eingebaut werden, habe ich mich zum ersten Mal dazu entschieden, mir die Freiheit zu nehmen, nur anzugeben, dass die Bilder auf 4 Kontinenten, in 14 Ländern und in 28 Städten aufgenommen wurden, ohne den jeweiligen Ort den Fotografien zuzuordnen.

Unzählige Menschen haben mir während meiner Reisen geholfen und werden mir vergeben, wenn ich nicht jeden einzeln erwähnen kann. Michael Glasmeier ist der treffende und intelligente Text zu verdanken, für welchen ich mich geehrt fühle. Besonders dankbar bin ich Markus Hartmann vom Hatje Cantz Verlag für sein Vertrauen in meine Arbeit. Die wunderbare Grafikerin Indra Kupferschmid hat zum zweiten Mal ein Buch für mich gestaltet, für das ich sie erneut küsse. Meine Lehrtätigkeit an der Hochschule für Künste in Bremen und die Diskussion mit den Studierenden hat mich dazu gezwungen, noch genauer über meine eigene Arbeit nachzudenken. Es war ein Privileg, mit euch allen zu arbeiten! Peter Rautmann, Peter Schäfer und Markus Wortmann haben meinen Drang unterstützt, von der Hochschule in den Rest der Welt aufzubrechen; ohne sie würde es ziemlich viele Bilder nicht geben.

Weiteren Dank an: Ruth Eichhorn für ihre Unterstützung meiner Arbeit in Dubai; Anna Gripp und Denis Brudna für ihre Freundschaft und ihre Bereitschaft zu debattieren; Heiko Sievers vom Goethe-Institut für seine Berichte über Gurgaon und dass er mich und meine Arbeit nach Indien brachte. Und vor allem ein großes Dankeschön an meine Freunde, die, wie immer, für mich da waren, wenn ich sie gebraucht habe.

Peter Bialobrzeski
Hamburg, Mai 2007

Impressum

Copyediting/Lektorat
Monika Reutter, Julika Zimmermann
(German/Deutsch),
Donna Stonecipher (English/Englisch)

Translation/Übersetzung
Melissa Thorson Hause

Graphic design/Grafische Gestaltung
Indra Kupferschmid

Typeface/Schrift
Monotype Grotesque 215

Paper/Papier
Galaxi Supermat, 170 g/m²

Binding/Buchbinderei
Conzella Verlagsbuchbinderei, Urban
Meister GmbH, Aschheim-Dornach

Reproductions and printing/
Reproduktion und Gesamtherstellung
Dr. Cantz'sche Druckerei, Ostfildern

Published by/Erschienen im
Hatje Cantz Verlag
Zeppelinstrasse 32, 73760 Ostfildern
Germany/Deutschland
Tel. +49 711 4405-200
Fax +49 711 4405-220
www.hatjecantz.com

ISBN 978-3-7757-2049-6
Printed in Germany

Cover illustration/Umschlagabbildung
Transition 20

Page/Seite 9
Transition 00

A Collector's Edition of this book is
available with an original work by the
artist illustrated as *Transition 12*,
2005, C-print, sheet size: 30 x 40 cm, in
an edition of 30 plus 5. Please contact
Hatje Cantz for more information.

Es erscheint eine Collector's Edition
mit einer Originalarbeit des Künstlers,
abgebildet unter *Transition 12*, 2005,
C-Print, Blattformat: 30 x 40 cm, in
einer Auflage von 30 + 5 Exemplaren.
Nähere Informationen erhalten Sie
beim Verlag.

Hatje Cantz books are available
internationally at selected bookstores
and from the following distribution
partners:

USA/North America: D.A.P.,
Distributed Art Publishers, New York,
www.artbook.com
UK: Art Books International, London,
www.art-bks.com
Australia: Tower Books, Frenchs Forest
(Sydney), *www.towerbooks.com.au*
France: Interart, Paris, *www.interart.fr*
Belgium: Exhibitions International,
Leuven, *www.exhibitionsinternational.be*
Switzerland: Scheidegger,
Affoltern am Albis, *www.ava.ch*

For Asia, Japan, South America, and
Africa, as well as for general questions,
please contact Hatje Cantz directly at
sales@hatjecantz.de, or visit our home-
page *www.hatjecantz.com* for further
information.